YORKSHIRE CHURCHES
THROUGH TIME
Alan Whitworth

AMBERLEY PUBLISHING

RIP
For my brother and his family, who are at last becoming a fading memory. On a happier note, I should like to dedicate this work to Peter Burman and David Williams both formerly of the Council for the Care of Churches, London who encouraged me in the days of my 'church spotting'.

First published 2011

Amberley Publishing
The Hill, Stroud
Gloucestershire, GL5 4EP

www.amberley-books.com

Copyright © Alan Whitworth , 2011

The right of Alan Whitworth to be identified as the Author of this work has been asserted in accordance with the Copyrights, Designs and Patents Act 1988.

ISBN 978 1 4456 0667 5

British Library Cataloguing in Publication Data.
A catalogue record for this book is available from the British Library.

Typeset in 9.5pt on 12pt Celeste.
Typesetting by Amberley Publishing.
Printed in the UK.

Introduction

Many parish churches and chapels are the oldest building in their town or village; some of them may be over a thousand years old. Throughout their long history churches and chapels have usually witnessed change, sometimes beyond recognition. Countless churches bear the scars of trials and tribulations, the effects of war, restorative vandalism, parochial indifference and the zeal of Puritanical iconoclasts. However, although their congregations have dwindled and almost everywhere the upkeep of the building is becoming beyond the resources of those who generally use it, the vast majority do show a great evidence of loving care and generous devotion.

With the millennium year came a wave of interest in Christianity and equally with the church building itself and the role it plays in modern society. Indeed, since the late 1970s, if not before, churchmen and conservationists have had to address the growing problem of declining congregations and the resultant necessity to make churches and chapels, which are not adequately used, face redundancy.

In a first attempt to draw attention to the plight of the English parish church and its value as a tourist resource, the Society for the Promotion of the Preservation of English Parish Churches (SPEC) organised a two-day conference in 1980 at Bradford Cathedral entitled 'The Art of Church Management'. The conference attracted representatives of the leading Church organisations, many of whom also contributed to the event.

In the next year, following on from the SPEC conference, the Council for the Care of Churches (the CCC) prepared a report, 'Churches and Visitors' which was debated by the General Synod of the Church of England. The General Synod concluded its debate by agreeing to commend to the dioceses and parishes key suggestions made in the report for the encouragement of visitors to churches. The CCC also submitted a paper to the English Tourist Board entitled 'Churches and Tourism: The Next Steps', which outlined the need for further research into many areas then under discussion.

In January 1997 the English Tourist Board sent out a questionnaire to two hundred churches identified in the past as attracting the most visitors. Seventy-seven churches replied with visitor details. These churches attracted about 3.5 million visitors in 1996 who spent a total of £2.5 million; fifty-one per cent of this total was spent on guidebooks and souvenirs, thirty-eight per cent on donations, and eleven per cent on other items or services such as catering, admission to the tower, and brass rubbing.

At last, those interested in fusing the church with visitors began to respond and harness the rewards. St Mary's church, perched high on the clifftops at Whitby, North Yorkshire, is one such success story that has managed the balance between Mammon and God. The sale of items not only includes the usual paraphernalia of guidebooks and postcards, but Christian literature and verse. Also, through the medium of a splendid locally produced audio-visual presentation (that tourists pay extra to watch) set up in a quiet transept, visitors are brought into closer proximity to the Christian experience as the presentation explains the architecture, history and role of St Mary's in the community. But perhaps more importantly, through visitor revenue, it has raised substantial sums for the upkeep of the building and other parish projects.

Above the parochial level, other success stories include the initiative of the Lincoln Diocese who tackled the problem head-on with the appointment of a Church Tourist Officer. The appointment was made possible an award from the Ecclesiastical Insurance Group in 1980 in a national competition to encourage the development of church tourism in celebration of their centenary.

In other areas the church was forced into moving with the times. SPEC and the CCC organised a church guide competition to promote the better design of these often overlooked but highly important resources, for a small church guide is often what the visitor takes away from his visit. Later, SPEC took this national competition on and organised the second and third National Church Guide Competition, held every two years.

Today, the church building as a tourist resource is almost universally accepted and it is almost taken for granted that it should be open and have material of a professional standard for visitors. The rewards for both visitor and church when this is managed correctly are incalculable. Within a church building there is always something to interest everyone, as all churches are a vast store of the country's best in art, architecture and sculpture.

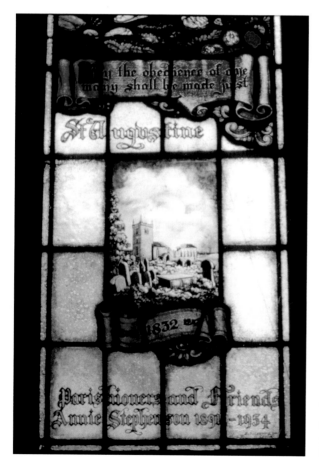

The old church at Woodkirk was destroyed by fire. The event was recorded in this stained glass window in the new church of St Mary.

Addingham, St Peter

Addingham, St Peter is mostly of eighteenth-century date with later Victorian restoration work. There are nevertheless a number of medieval features and a fine fragment of a late Anglo-Saxon cross suggesting a much earlier foundation. Of particular interest is the original nave roof dating back to around 1475. The Yorkshire entrepreneur Samuel Cunliffe Lister (1815–1906), 1st Baron Masham, is interred here. A possibly unique feature is that a cutting of the famous Glastonbury Thorn was planted in the churchyard and is thriving.

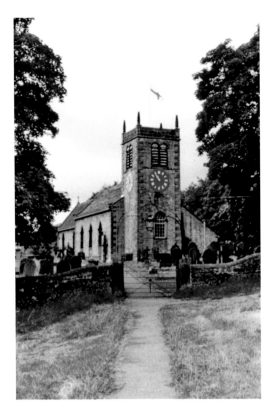

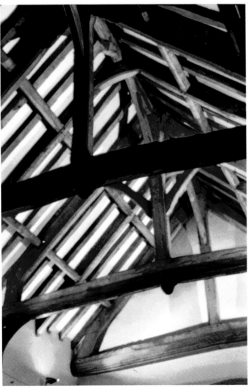

Adel, St John the Baptist

The church of St John the Baptist at Adel, near Leeds is one of the finest complete Norman churches in Yorkshire. Dating from the mid-twelfth century, it has a magnificent textbook south door with its many orders and a carving of Christ in Majesty, above which is the tympanum with a Paschal Lamb and the four symbols of the Evangelists. The door itself is original with a closing ring of bronze depicting a monster swallowing a man. There is sumptuous carving without in the corbels, and within, an elaborately carved chancel arch.

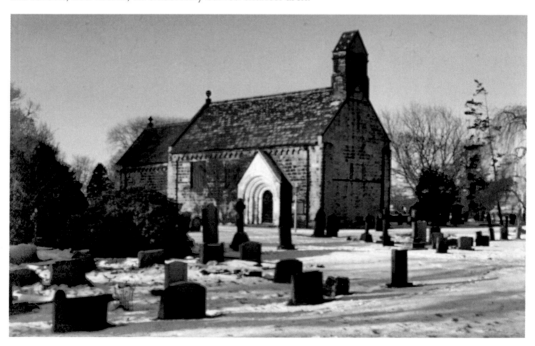

Almondbury, All Hallows

The church of All Hallows, Almondbury, near Huddersfield is essentially a late fifteenth-century edifice. A very fine nave ceiling, decorated with carved bosses and long inscribed frieze dating from 1522, survived the nineteenth-century restoration which took place around 1896 when the rood screen was removed (above). The tall font cover of about the same date as the roof is one of the finest in the county. Good fragments of fifteenth-century stained glass in the Kaye Chapel depict saints and members of the family. The family pew is dated 1605.

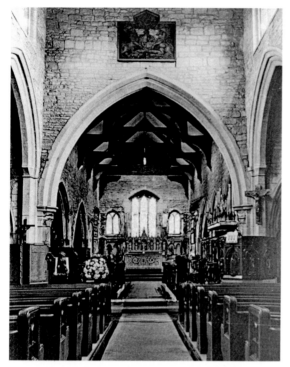

Almondbury, All Hallows
Almondbury, All Hallows photographed soon after the elaborately carved wood rood screen had been removed around 1896 as part of the Victorian restoration. Possibly in hindsight this was a mistake, but one can see that at the time the idea was to open up the interior and provide the congregation with a view of the altar. The term 'rood' is the old name for a crucifixion cross and the rood screen would support this, which filled the remaining space of the chancel arch; many were destroyed during the Commonwealth period.

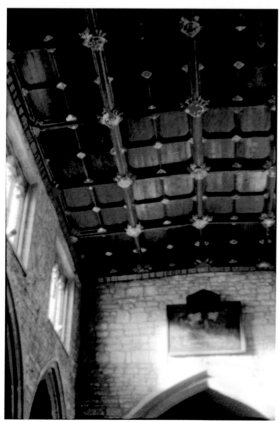

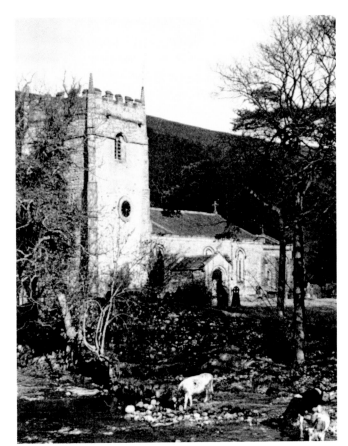

Arncliffe, St Oswald

The church of St Oswald at Arncliffe in North Yorkshire has a beautiful dales setting. Although substantially remodelled in 1841, it still retains its mid-fifteenth-century tower with a bell from the previous century, dated 1350, and some windows of Perpendicular style. Inside, the church is of great interest In particular, there is a list of all the Dales men who fought and died at Flodden Field in 1513.

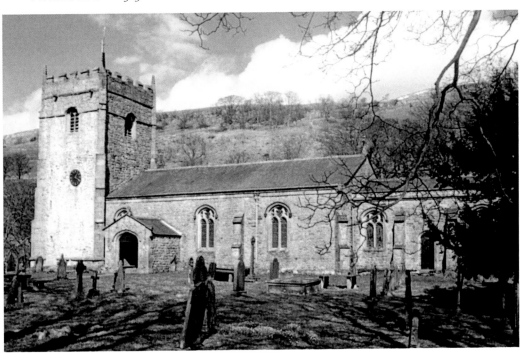

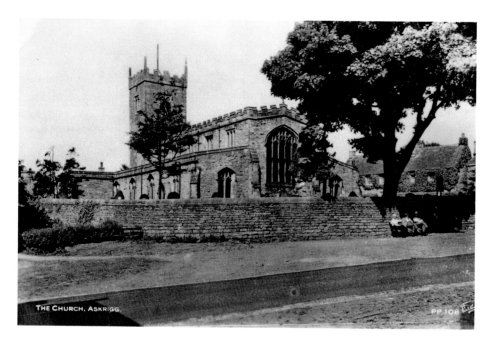

THE CHURCH, ASKRIGG. PP 108

Askrigg, St Oswald

The church of St Oswald at Askrigg is possibly the most impressive church in Wensleydale. An almost complete, late Perpendicular edifice, it has a fine nave ceiling with powerful moulded beams that is one of the finest in the North Riding. There is also an interesting tower vault. It had no structural division between nave and chancel, and in recent years the chancel has been adapted so that it can be used for drama and music; this remodelling may not be to everyone's taste.

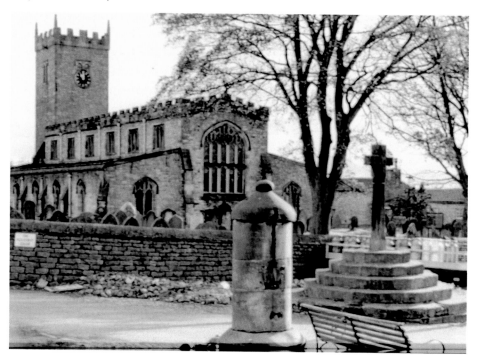

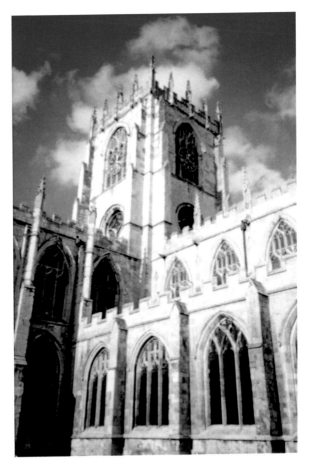

Beverley, St Mary

The church of St Mary at Beverley in the East Riding is often mistaken by the first-time visitor for the Minster. The building is beautiful and big, cruciform in plan with a magnificent central tower decorated with pinnacles and crockets dating from the 1520s. This is the second tower to St Mary's. The first medieval tower collapsed. There is a superb west front with great window and twin towers. Of particular interest inside the church is the chancel arch, which was painted in 1445 with pictures of forty English monarchs, although some are mythical.

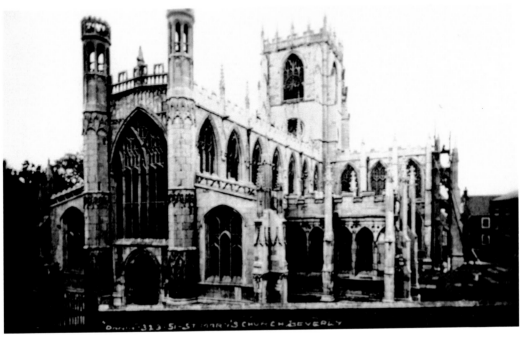

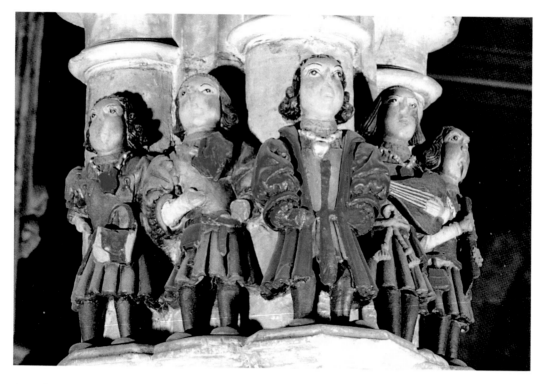

Beverley, St Mary's

The interior of St Mary's is amazing, and contains many fine carvings. One of these is a rabbit which is said to have been the inspiration for Lewis Carroll's white rabbit in the Alice books. There is also this little group of musicians on a pillar dating to 1526. The medieval Northern Guild of Minstrels was centred on Beverley, which explains this iconic sculpture among the many spectacular decorations within Yorkshire churches.

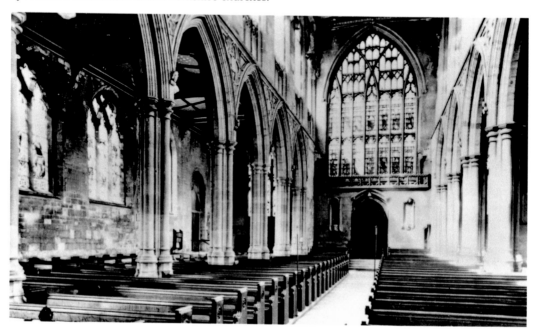

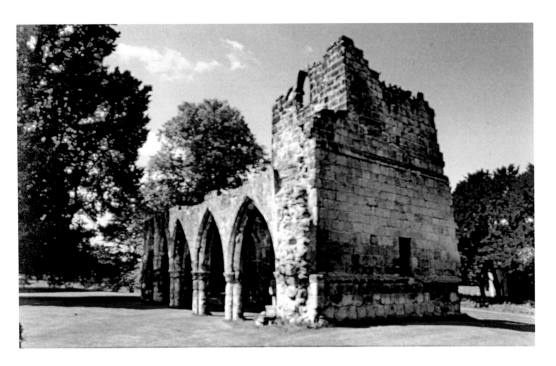

Birdsall, St Mary's

The remains of the old church of St Mary at Birdsall, North Yorkshire, sit dramatically on the manicured front lawn, within a stride or two of the front door to the Hall. A Norman chancel arch survives and the tower carries this shield with the family coat of arms and the date 1601. This edifice was replaced by a new church in the village in 1832, with a later chancel added in 1880 by Hodgson Fowler. Into this were placed many interesting monuments from the redundant church including a fourteenth-century effigy of a lady.

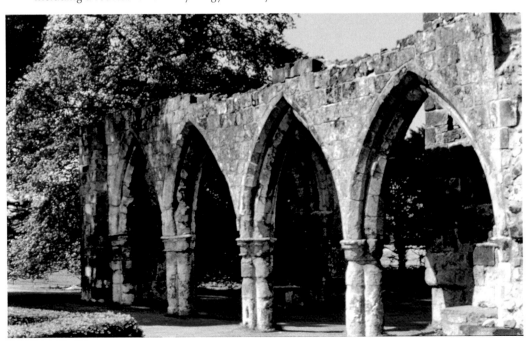

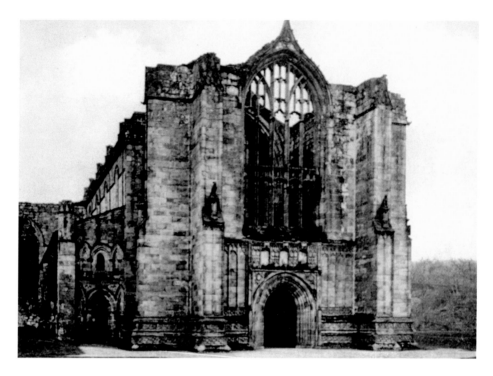

Bolton Abbey, Blessed Virgin and St Cuthbert

Bolton Abbey is the name of the village. The nearby romantic ruins of the great Augustinian priory of the Blessed Virgin and St Cuthbert are more correctly known as Bolton Priory. The Priory church survived the Dissolution, and although part-ruined, it still serves the village community as a handsome parish church. The nave, restored by George Edmund Street in 1880, is Early English and has a superb west front partly obscured by the equally impressive west tower dating from 1520, though never completed.

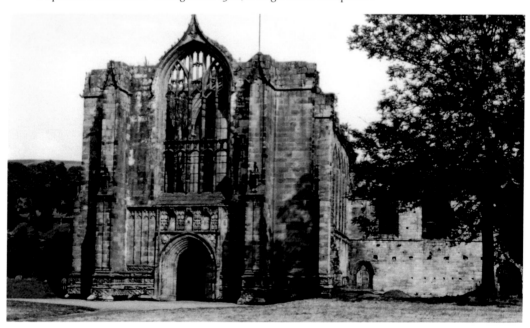

Bradfield, St Nicholas

Bradfield, St Nicholas is a fine, large church of fourteenth- and fifteenth-century date with masonry from an earlier edifice. It has a good medieval nave roof with moulded beams and carved bosses. There is Tudor period glass in the north windows and a brass of 1647 showing John Morewood, his wife and their fifteen children. However, the real interest of this church is to be found in the churchyard; a watch house erected to provide shelter for the persons employed to protect the graves from bodysnatchers in the nineteenth century.

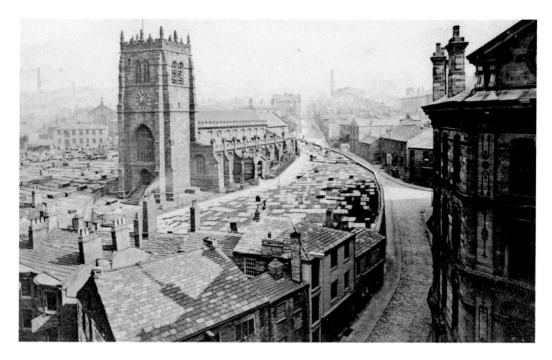

Bradford, St Peter

The parish church of St Peter, now a cathedral, and Church Bank c. 1880. The site of the first market in the thirteenth century, a great deal of the churchyard and a cluster of dwellings known as The Rookery disappeared within fifty years of this photograph being taken. The warehouse to the right marks the start of 'Little Germany', an area noted for the quality of its merchant warehousing. Cleared of 'old Bradford', the vicinity of upper Church Bank and Stott Hill for a period became a desirable residential area.

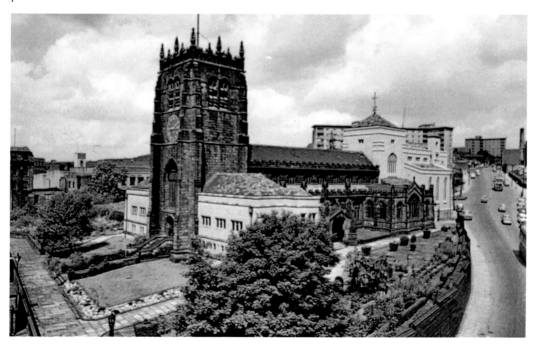

Bradley, St Thomas's

The interior of St Thomas's church, Bradley, shortly after opening in August 1863, showing the white Caen stone pulpit on the left which was replaced in December 1944 with a carved wood one (below). This was designed by Sir Charles Nicholson, and constructed by Bowman and Sons, of Stamford, Lincolnshire. The actual panels were carved by Faust Lang, of Oberammagau, the village which hosts the world famous Passion Play. The pulpit was provided as a gift for the memory of Mr and Mrs Brearley, of Bradley Hall Farm.

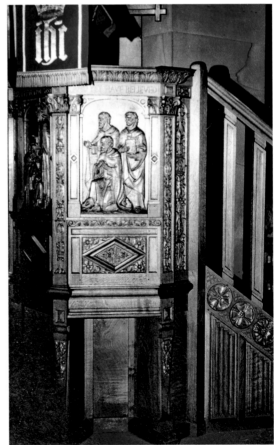

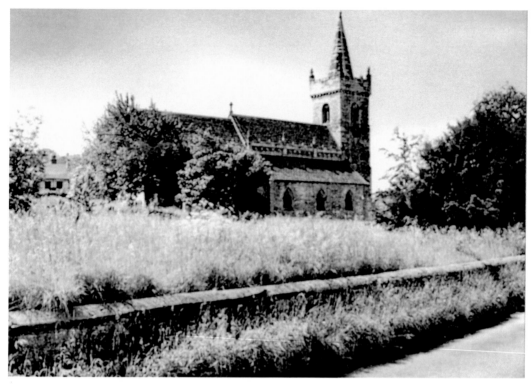

Bramham, All Saints

The West Yorkshire church of All Saints at Bramham has interesting corbelled battlements on the south wall of the nave in the Perpendicular style. The church sits in an enormous oval churchyard that could denote a very ancient church site, especially given the survival Norman work surviving from an earlier building. Inside there is some unusual early twentieth-century screenwork and panelling in a mixture of Art Nouveau and Gothic style by Bromett and Thormman of nearby Tadcaster.

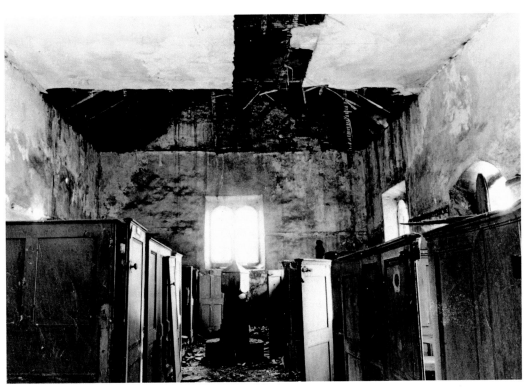

Bramhope Chapel

At Bramhope in the West Riding on the main road between Leeds and Otley, in the grounds of the demolished hall that is today occupied by a hotel, is one of the earliest Puritan chapels in the country. Erected by the lord of the manor in around 1649, it is complete with box pews and three-decker pulpit. The octagonal font is dated 1673. Badly neglected as can be seen in the upper photograph, it was fully restored in 1966 at the time when the modern hotel was built.

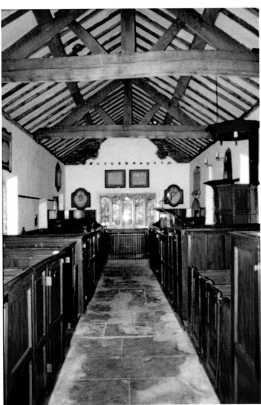

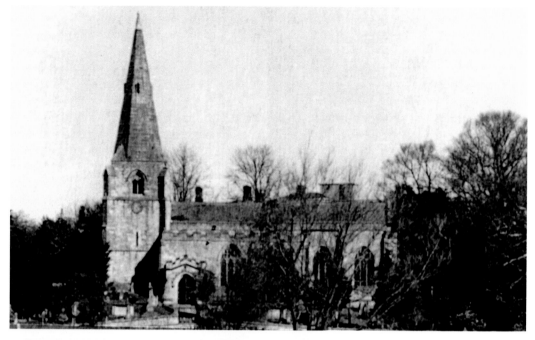

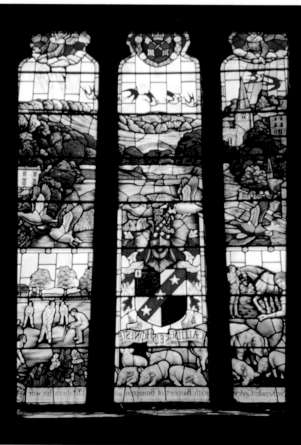

Brompton, All Saints

Of the numerous and beautiful stained glass windows in Yorkshire, it would be difficult to single out any one above another. There are many examples of ancient glass of superb quality, but equally there is modern glasswork of rare beauty to be found in numerous churches. I feel this modern piece at All Saints, Brompton is outstanding. It was here in this church of fourteenth- and fifteenth-century date that William Wordsworth, poet, was married in 1802. The impressive organ case is by Temple Moore, built in 1893.

Burneston, St Lambert

The church at Burneston in North Yorkshire with the unusual dedication to St Lambert, a seventh-century missionary bishop from Maastricht who was martyred in AD 700. A complete building of the fifteenth century, inside sadly the chancel arch is badly damaged. However, there is a splendid set of seventeenth-century pews with carved panels and bobbin ends, culminating in a three-decker family pew which bears a plaque recording that the seats cost £50 when made in 1627.

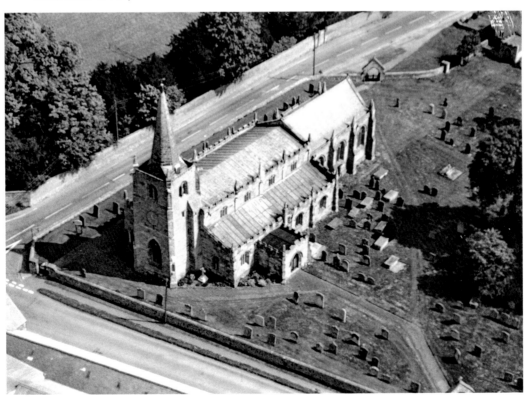

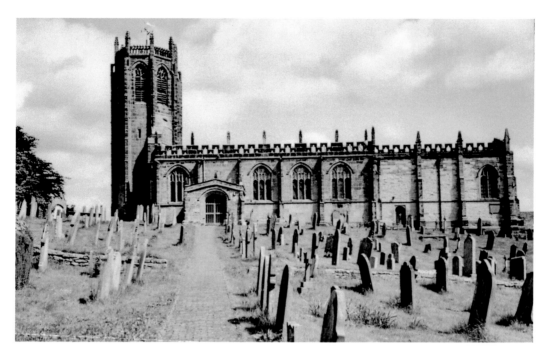

Coxwold, St Michael

The church of St Michael at Coxwold is one of the most splendid in North Yorkshire and has two unique features: its octagonal tower, the only one so shaped from the ground to crenellations, and the horseshoe-shaped altar rail (below) in the chancel, which is packed with monuments to members of the Fauconberg family. It had to be constructed in this manner as the only way to allow large numbers of communicants to kneel for Holy Communion.

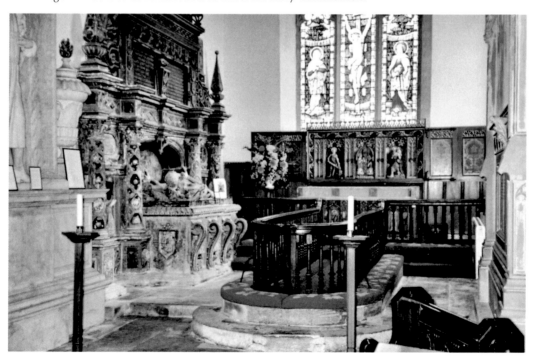

Elland, St Mary's

Elland church, dedicated to St Mary, is mostly Perpendicular in date, but the chancel arch below appears to date from the early thirteenth century if not the twelfth century. The tower is embraced by the aisles and transept chapel. The great treasure here is the east window stained glass of about 1470, depicting the life of the Blessed Virgin Mary. There are many other examples of medieval glass elsewhere, as well as modern glass by Kempe. There is also an early eighteenth-century monument by Horton and a nineteenth-century Nichols monument.

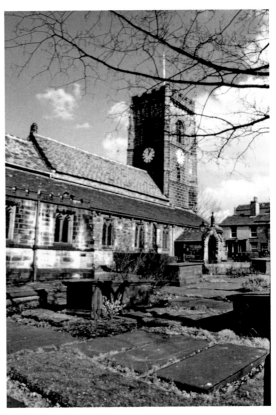

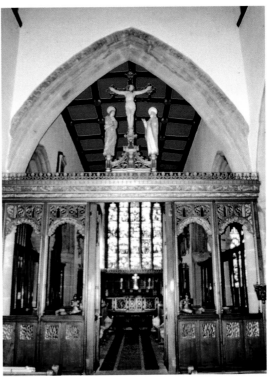

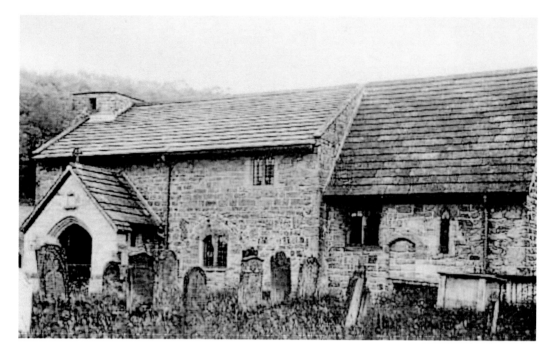

Ellerburn, St Hilda's

By taking a path from Thornton-le-Dale you can reach the secluded Ellerburn valley and the charming church of St Hilda. Carefully restored, it contains good examples of Saxon and Norman work. A former caretaker here once used the eighteenth-century pulpit to hatch his hen's eggs; the preacher had to give his sermons from the reading. In the churchyard, entered by a beautiful lychgate dated 1904, is a large, red granite Dobson monument of 1879 with a stone finial and Gothic detail.

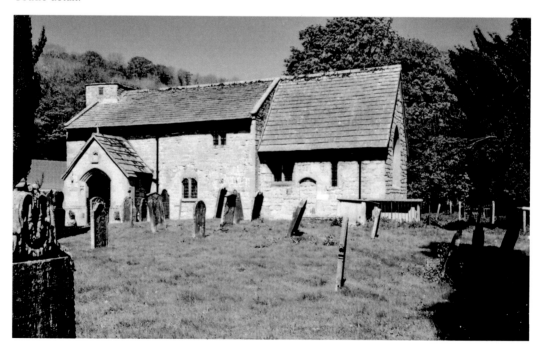

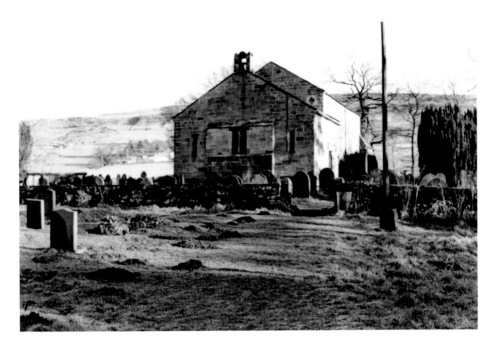

Farndale, St Mary's

The church of St Mary at Farndale sits in a valley through which flows the River Dove. It is famous for its wild daffodils (Narcissus pseudonarcissus), also known as the Lent Lily. It is thought that the monks from Rievaulx introduced the flower and over several centuries they have multiplied. The church was built to serve the scattered rural community in 1831, and was restored in the period 1907–14 by the eminent architect Temple Moore, who added the west front.

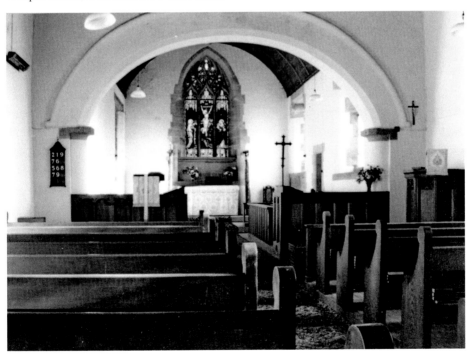

Giggleswick, St Alkelda and Giggleswick School Chapel

The village of Giggleswick is famous for its public school dating back to the seventeenth century. The magnificent school chapel below, with its rich interior, stands alone looking down on the school and village and is identifiable for miles around by its copper dome. The chapel was the gift of Walter Morrison, a curious millionaire who lived at Malham Tarn for sixty-four years. He attracted to the area the likes of John Ruskin, Charles Darwin and Charles Kingsley, who was inspired by the waters of the Tarn to start writing *The Water Babies*.

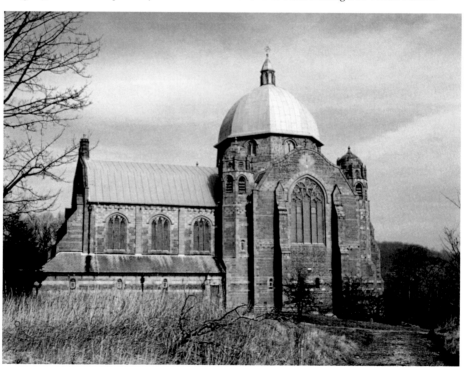

Guisborough, St Nicholas's

The church of St Nicholas at Guisborough originated as a chapel to the adjacent Augustinian priory. It was rebuilt around 1500 with further work carried out in the eighteenth and early-twentieth centuries. The outstanding treasure of this church, however, is the tomb chest known as the Brus Cenotaph (c. 1530) placed here from the priory after the Dissolution of 1539. The decoration includes a scallop shell of St James and cock on a reel; a rebus (pun) on the name James Cockerell who was prior at Guisborough (1519–34).

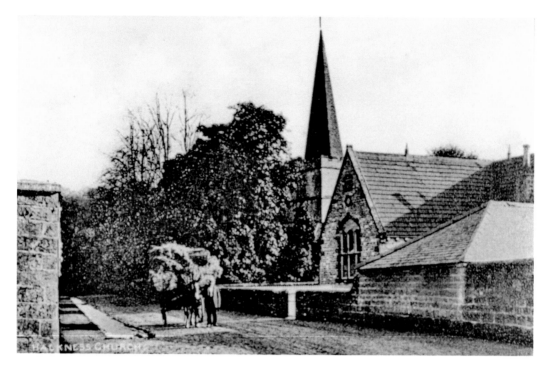

Hackness, St Peter's

The church of St Peter, Hackness, in the Forge Valley near Scarborough. The Saxon chancel arch and Norman work in the south arcade reveal its antiquity, despite the Victorian makeover. Two excellent fragments of an inscribed Anglo-Saxon cross link them to a convent founded here by St Hilda of Whitby. There is also a fine series of monuments by Sir Francis Chantrey and local-born Matthew Noble, and two exquisite Spanish-style candlesticks of seventeenth-century date.

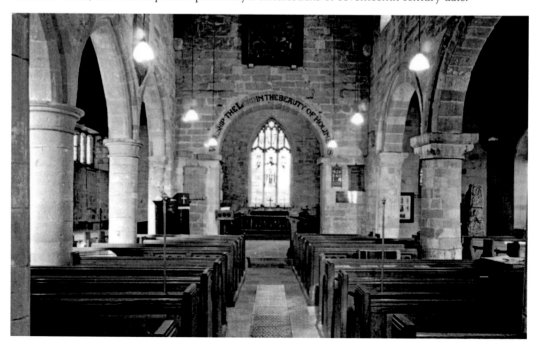

Halifax, St John the Baptist

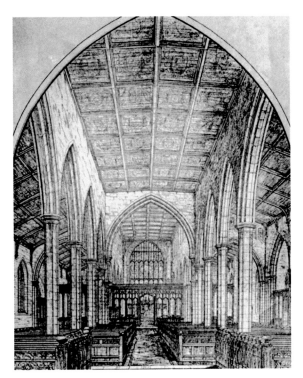

Above, the interior arrangement of the parish church of St John the Baptist, Halifax, as proposed by Sir George Gilbert Scott, RA. The church is mainly fourteenth-century Perpendicular work with some marvellous fifteenth-century woodwork in the stalls and spire-shaped font cover, as well as later woodwork, in particular the roof. During the Civil War most of the glass was lost, but the Puritan General Lord Fairfax a had the church reglazed with clear glass and stunning leadwork at his own expense. Below, a life-sized figure of Old Tristram for an alms box.

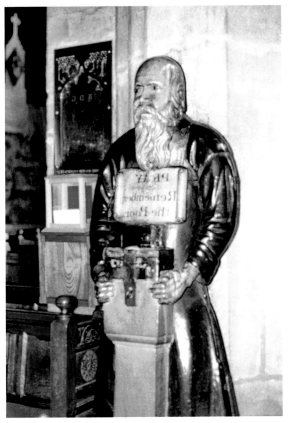

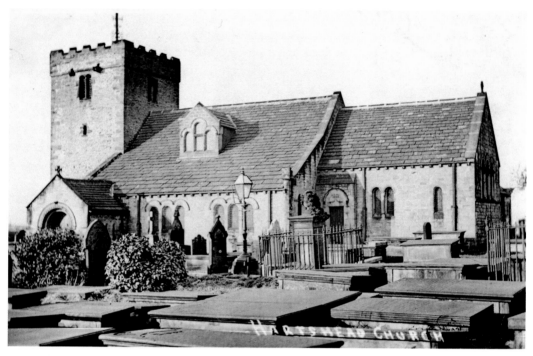

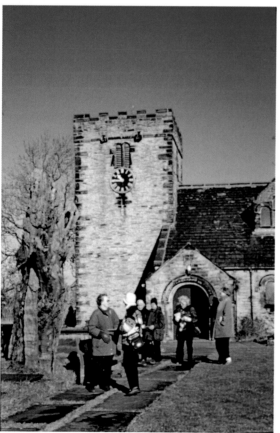

Hartshead, St Peter's

St Peter's, Hartshead, has some notable connections, firstly to Robin Hood and secondly to the Revd Patrick Brontë who was incumbent here from 1810–15 before moving to Thornton. The south doorway, chancel and west tower are genuine Norman work but the rest is Neo-Norman dating from the restoration of the church in 1881. The Robin Hood connection is that this famous outlaw is buried nearby in the grounds of Kirklees Hall, as part of the remains of Kirklees Priory, where Robin died at the hands of the 'wicked prioress'.

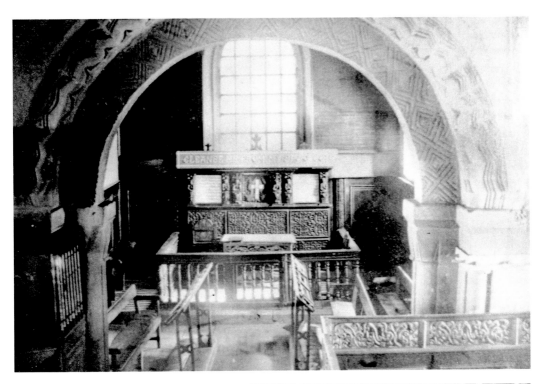

Hartshead, St Peter's

The upper photograph shows the
chancel before restoration. The
chancel arch is textbook Norman
– round-headed with typical chevron
moulding decoration. Below, the
chancel after restoration shows that
the architect was sympathetic to
the old architecture and the interior
more or less remains intact. The
beautiful chandelier dates to the
seventeenth century and carries a
long inscription commemorating
Patrick Brontë's incumbency here.
He witnessed the Luddite riots
and the unlawful burials in the
churchyard at night of those killed,
of which he wrote that he was too
frightened to interfere.

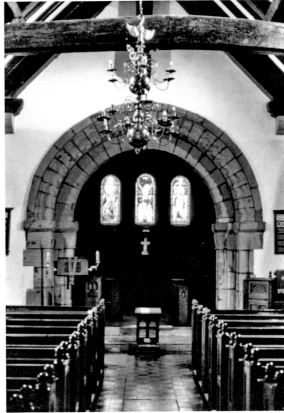

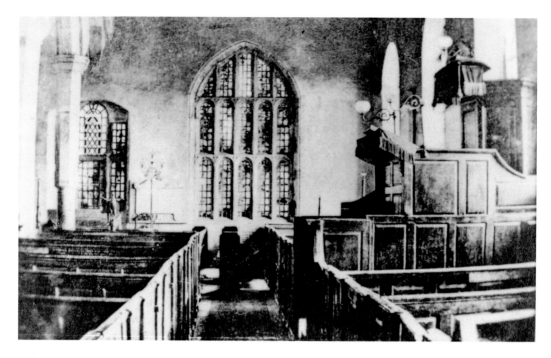

Haworth, St Michael's

The church of St Michael at Haworth, below, would not be recognised today by the Brontë family, it is built on an entirely different plan to the old church above. Nevertheless Haworth and the church is a place of pilgrimage for all Brontë lovers, for here the Revd Patrick Brontë was the incumbent, 1820–61. A brass plate near the chancel screen marks the site of the Brontë vault. A marble tablet in the Brontë chapel records the names of all the family, but Anne was buried alone at Scarborough where she died.

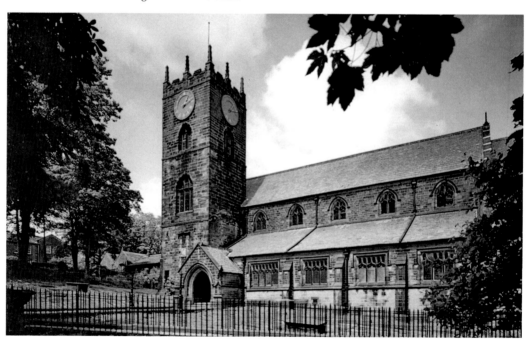

Heptonstall Methodist Church

Heptonstall Methodist church, built in 1764 on the slope below Westgate, at the edge of the village. This octagonal chapel building is thought to be the oldest Methodist chapel in continuous use to the present day. It was partly rebuilt in 1802. The interior of Nonconformist chapels were built to hear the 'preaching of the word', therefore they were arranged so that the congregation could focus on the pulpit. John Wesley the founder of the Methodist movement enjoyed preaching here. John Wesley was born at Epworth in Lincolnshire in 1709. He was a Church of England minister but broke away to form the Wesleyan Methodist Society. In his lifetime Wesley travelled 250,000 miles throughout Britain preaching the message of God. He and his brother Charles wrote many popular hymns that are sung even today. Charles once said of hymn writing, 'Why should the Devil have all the good songs?'

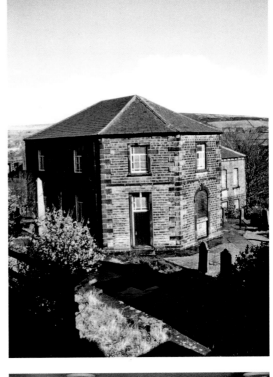

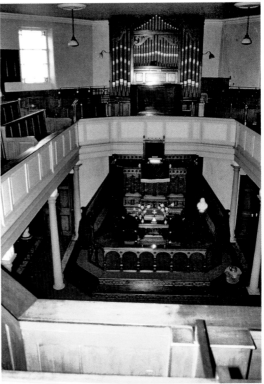

Heptonstall, St Thomas Beckett and St Thomas the Apostle

There are two churches at Heptonstall separated only by the graveyard. The old church of St Thomas Beckett (top) was badly damaged by storm in 1847, after which it was found more expedient to build a new church rather than repair it. Near the porch is the grave of David Hartley, who was executed at York in 1770 for making counterfeit coins. The new church (bottom), erected between 1850 and 1854, is dedicated to St Thomas the Apostle and is a good example of Victorian Gothic. The original undistinguished furnishings were removed in the early 1960s to permit the creation of the rather splendid, if controversial modern interior. However the original and unusual eleven-sided font from the old church is retained.

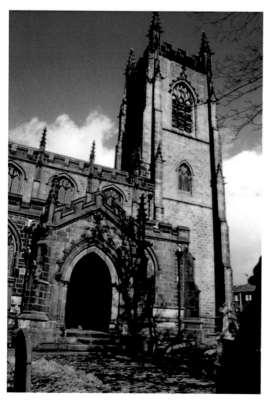

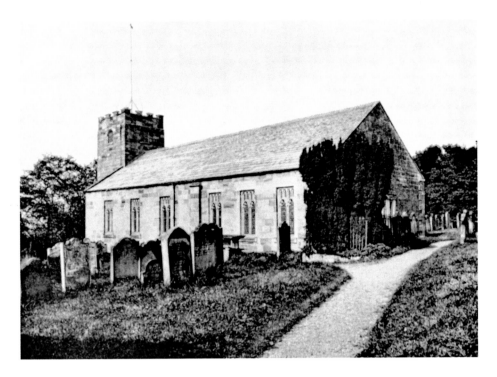

Hinderwell, St Hilda's

Hinderwell is a village which stretches along the road between Staithes and Whitby. At the north end of the village the parish church of St Hilda stands on a grassy knoll. From the hillside beside the church trickles a spring – St Hilda's Well – which has existed for centuries, giving the village its name. In the Middle Ages it became a place of pilgrimage, however it is obvious that the well was used a source of water for the village. The well shelter was restored in 1912 by Hilda Palmer of nearby Grinkle Park.

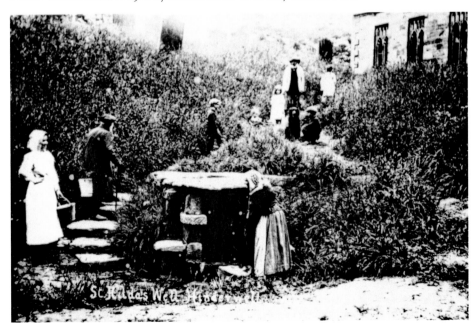

Denton, Wakefield and John Carr

St Helen's at Denton is by the famous York architect John Carr (1723–1807). Perhaps best noted for his masterpiece Harewood House among many great mansions, he was also a prolific designer of churches. Denton is a complete and unspoilt private chapel in the Gothick style dating from 1776. The east window has painted glass of about 1700 by Henry Gyles, said to have come from the nearby hall. Among his church designs his masterpiece must be Horbury which he erected at his own expense and within which his body lies. Carr had many emulators. The church of St John, which dominates St John's Square in Wakefield, was built by Charles Watson in a similar style to Carr. It has an excellent interior, although the east end was designed by John Thomas Micklethwaite in 1905.

Howden, St Peter

The parish church of St Peter, at Howden, commonly called Howden Minster. It is a large and magnificent cruciform church with a tall tower, which was central until the choir collapsed in 1696 and the chapter house lost its roof in 1750. The church is of Norman foundation. Some masonry from this period has been reused, but the building mostly dates from 1267 when the church was made a collegiate. The interior is sumptuous and there is a superb pulpitum from the ruined part and recycled as a reredos. On the south side is attached the grammar school, which dates from around 1500.

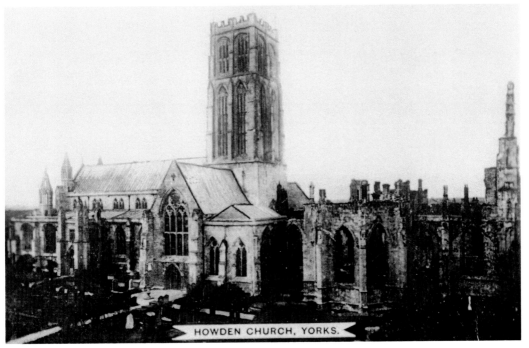

HOWDEN CHURCH, YORKS.

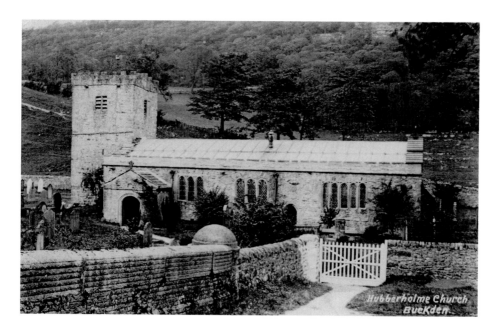

Hubberholme, St Michael's

There is Norman work in the tower of St Michael's church at Hubberholme, and perhaps more can be identified in the south arcade, although this could just be crude local work of fifteenth-century date. The north arcade is of fifteenth-century date also. However, the entire church was restored by Ewan Christian in 1863. There is a font which is dated 1696, but may be from much earlier. Some of the glass is modern. Particularly notable is that designed by Francis Skeat of Harden, completed in 1970, which illustrates scenes from the history of the parish.

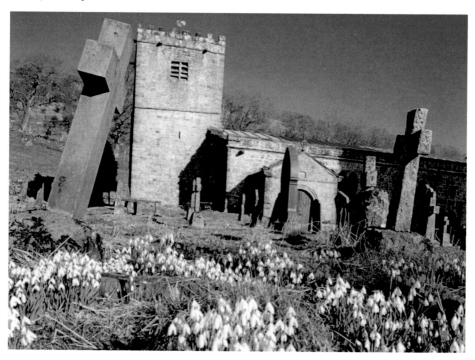

Hubberholme, St Michael's

The treasure at St Michael's, Hubberholme, is undoubtedly the rood loft and screen, one of only two in Yorkshire, and remarkable for its late date of 1558. Evidence of the previous existence of a rood loft in a church is a doorway, and possibly stone stairs, near the chancel arch. the vicar had to have access to the rood loft on certain holy days as it would form part of a processional way. The more modern woodwork is by Thompson of Kilburn, the 'Mouseman', and bears his famous trademark.

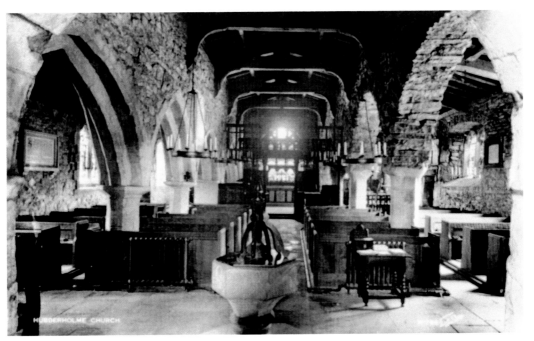

THE ROOD SCREEN. HUBBERHOLME CHURCH. 12010

HUBBERHOLME CHURCH

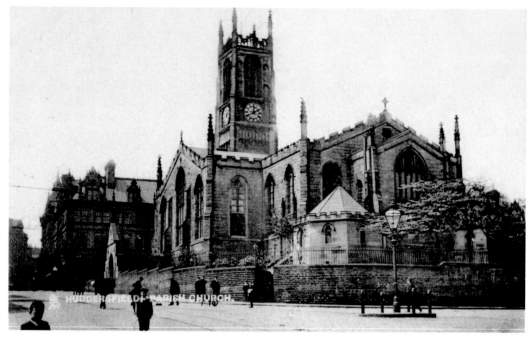

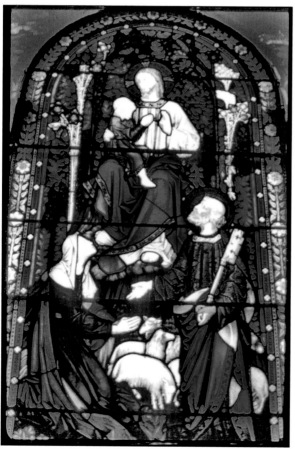

Huddersfield, St Peter's

The old Norman and medieval parish church of St Peter, Huddersfield, was rebuilt in 1836 by James P. Prichett of York, whose most notable architectural contribution to the town was the railway station. It has an interesting interior with a rare font of 1570 displaying the royal arms of Elizabeth I. The altar canopy and east window glass are the work of Sir Ninian Comper and date from 1921. A plaque records the remarkable record of a father and son who between them served as organists from 1812 to 1904.

Ilkley, All Saints

The parish church of All Saints in the West Yorkshire town of Ilkley was largely rebuilt in 1860 but retains a thirteenth-century doorway and fifteenth-century west tower. Inside there is a fine effigy of an early fourteenth-century knight and among the seating arrangements is a pew dated 1633. Elsewhere there is a significant collection of Anglo-Saxon crosses and mutilated Roman altars used in the building of the first church. The three most important crosses once stood outside but all have now been gathered together into a splendid display.

Kirby-in-Cleveland, St Augustine

The church of St Augustine at Kirby-in-Cleveland is a mixture of Georgian and Edwardian architecture. However, it stands on the site of an earlier edifice, the foundations of which were discovered in 1951 by the sexton while digging a grave. There are also Saxon and Norman carved fragments built into the present fabric. A new church replaced the older structure in 1815. In January 1839 a storm blew out windows on the south side, which were patched up. Further patching added to the unsightliness of the church and with the arrival of a new vicar in 1903 a decision was made to carry out refurbishment. In April 1905 work began and was completed by February 1906; the new building was opened on Thursday 19 April 1906. A fascinating story is told that a local boy interested in photography took a series of glass slides of the work in various stages of progress, but only two days after the new chancel roof was finished, the slides fell from the boy's hands and slid down behind the new slates. The foreman would not allow the roof to be lifted and there they remain.

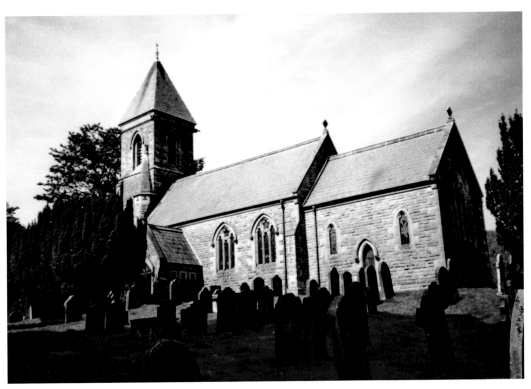

Kildale, St Cuthbert's

The church of St Cuthbert at Kildale
was rebuilt in the year 1868. The edifice
it replaced was described as an 'old,
dilapidated, tasteless, un-churchlike
building'. The new church, built near
to the railway station and reached via
a footbridge over the train lines, was in
the Early English style and erected to
the design of Fowler Jones of York. It
comprises a bell tower, nave, north aisle,
chancel and vestry. In the churchyard are
some early pieces of carved masonry.

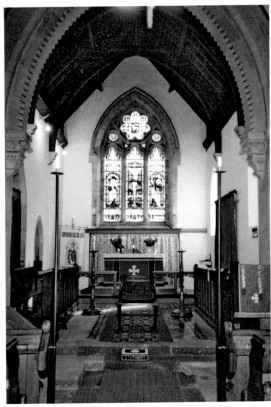

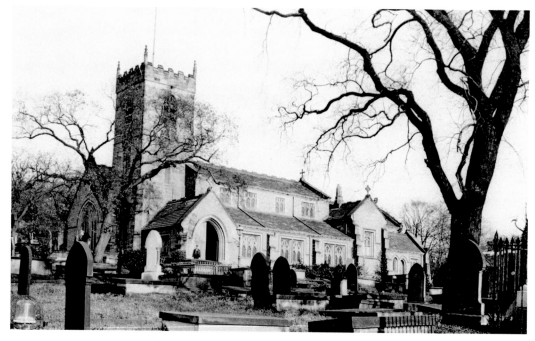

Kirkheaton, St John's

The church of St John at
Kirkheaton, near Huddersfield, was
ravaged by fire in 1886 and the only
survivors were the fifteenth-century
tower and the north chapel with
its monuments to the Beaumont
family, including the recumbent
effigy of one known as 'Black Dick',
dated 1631. Among the fragments
of Saxon and medieval sculpture
is a stone with a runic inscription.
In the churchyard is a memorial
to seventeen children who died in
a nearby cotton mill fire in 1818,
unable to escape because they had
been locked in overnight to work.

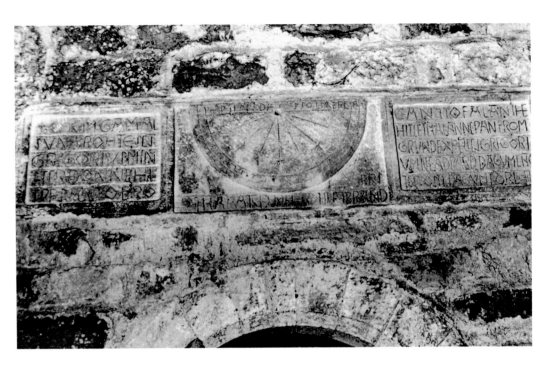

Kirkdale, St Gregory's

The Saxon sundial at St Gregory's Minster, Kirkdale, is the best of its kind in existence. The inscription tells how 'Orm, Gamal's son bought St Gregory's Minster when it was all broken down and fallen, and he let it be made anew from the ground to Christ and to St Gregory in the days of Edward the King and Tosti the Earl. And Haward [built it] and Brand [was the] Priest'. The text is in Northumbrian English and dates to the period 1055–65.

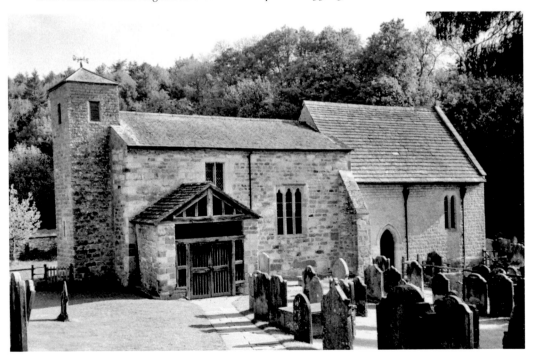

Knaresborough, St John the Baptist

The church of St John the Baptist at Knaresborough dates largely from the thirteenth to fifteenth centuries. The original cruciform plan was lost in the fifteenth century when the transepts were destroyed and the nave and aisles rebuilt. The marks of the transept roofs, however, can still be seen on the tower, where there is also an excellent example of a church clock. The south chapel with its sedilia, piscina, niches and tomb recesses, is Early English. There is a Perpendicular font with a handsome font cover dating from around 1700, and Jacobean screenwork between the chancel and south chapel; the poor box dates to 1600. Many of the windows contain excellent examples of glass by the noted Arts & Crafts designer William Morris.

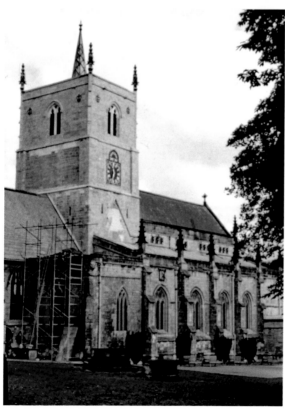

Knaresborough, St John the Baptist
Within the church at Knaresborough
are some interesting monuments
commemorating the dead of the
Slingsby family, including one to Sir
Henry Slingsby, who fought for King
Charles I at the battles of Marston
Moor and Naseby, showing him in full
cavalier costume. Another is that of
a past Reverend Sir Charles Slingsby
(*d.* 1869) laid recumbent with hands
clasped in prayer. Outside, at the edge
of the churchyard is a hearse shed
where the parish bier would be kept
between burials.

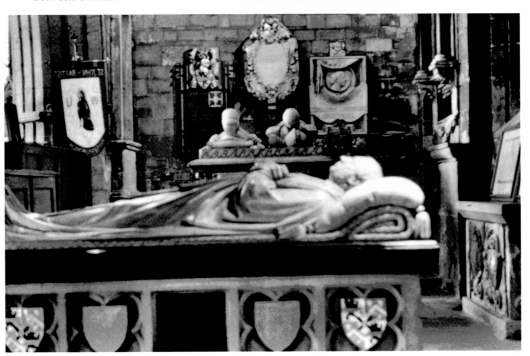

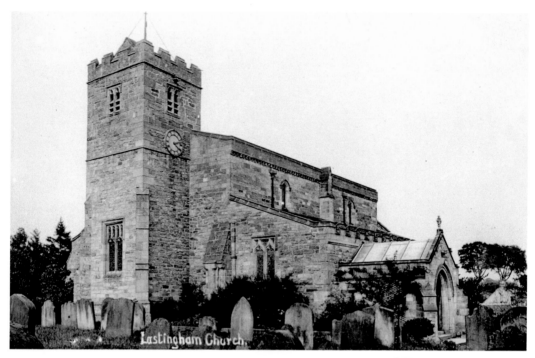

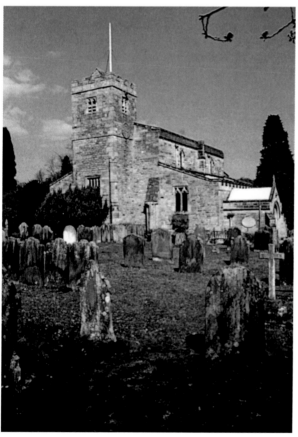

Lastingham, St Cedd's

Lastingham is an attractive village nestling on the edge of Spaunton Moor in North Yorkshire. It was in this sheltered retreat that St Cedd, a monk from Lindisfarne and Bishop of East Anglia, founded a church and monastery in AD 654. He is buried here after dying of a plague. Unfortunately, the monks were constantly attacked by Vikings raiders and abandoned the site in favour of St Mary's at York. As a consequence of this, the present church begun in 1228 is only part of a much larger building that was carefully restored in 1879.

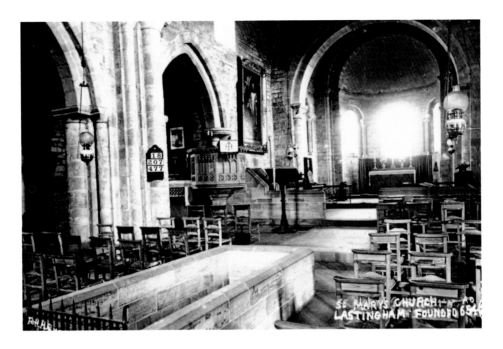

Lastingham, St Cedd's

However, despite the alterations and restorations, the apsidal crypt below the chancel, has not been altered for more than a thousand years, and is the only example which survives in England with chancel, nave and two side aisles. It was probably built by Abbott Stephen over the grave of St Cedd as a shrine for pilgrims and the two exits to the outside can still be seen as can the two passages inside from the crypt which are just blocked off.

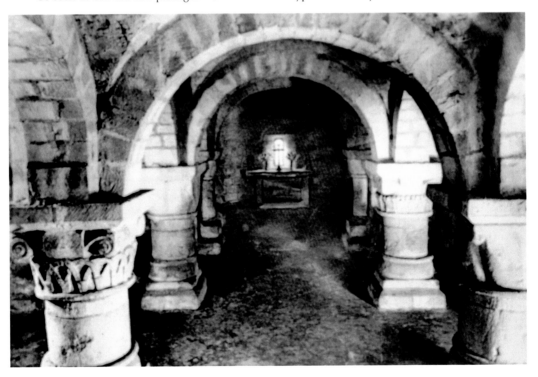

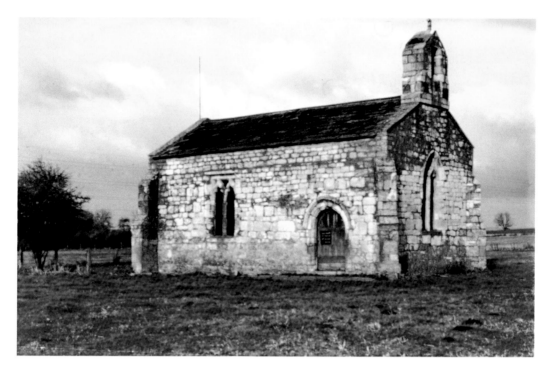

Lead, Unknown Dedication

The tiny church at Lead, which is without a dedication, stands alone in the middle of a field. The village it once served is said to have been overrun at the battle of Towton (1461), which took place nearby. The church itself was possibly used as a refuge for soldiers and even a place of burial for the bodies of those killed in battle. The floor is largely paved with medieval coffin lids, and one can be seen in the stone altar. Architecturally it dates from the early fourteenth century but was restored in 1784 when it received its pews and pulpit.

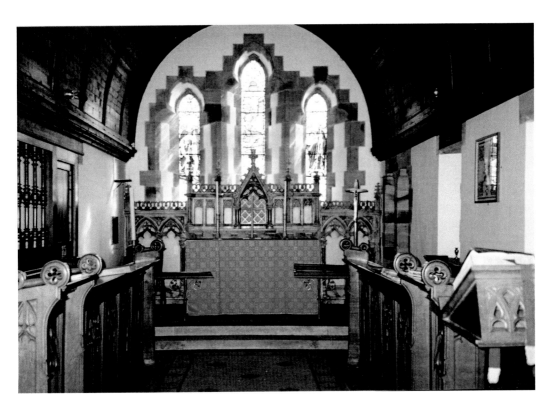

Lealholm, St James the Greater

The church of St James the Greater at Lealholm, known as Lealholm Bridge at this point, was designed by Temple Moore in 1902. A large proportion of the money needed to build the church was donated by the Ley family, who owned the estates around here. Inside are a number of memorials to members of the Ley family, whose ancestral home was in Nottinghamshire. St James's church was in fact erected as a chapel of ease to Glaisdale, which was the mother church, and responsible for marriages and burials.

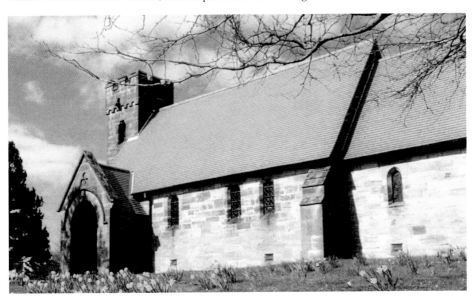

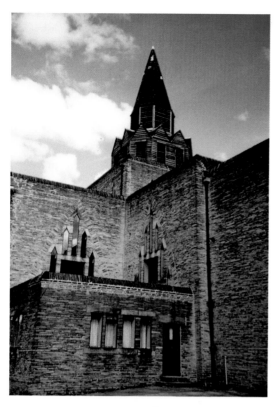

Leeds, Halton, St Wilfrid

The church of St Wilfrid, Selby Road, Halton is contemporary with Epiphany church at Gipton (1937–39), another Leeds suburb where the church was designed by N. F. Cachemaille-Day. Both represent the transition stage in ecclesiastical architecture following the Victorian Gothic revival. Here, the architect Randall Wells, in his last work, has produced a fascinating building marking the ultimate development of his own brand of Arts & Crafts architecture. He succeeded in constructing a much more modern looking building, although it retains some Gothic detailing. Inside, despite its stark simplicity, there is some good woodwork, especially the striking pulpit and a statute of the patron saint St Wilfrid by Eric Gill. The cost of St Wilfrid was met by the Sunderland shipbuilder Sir John Priestman, who had funded St Andrew's, Roker (Co. Durham), a not-dissimilar church where Randall Wells was E. S. Prior's architect.

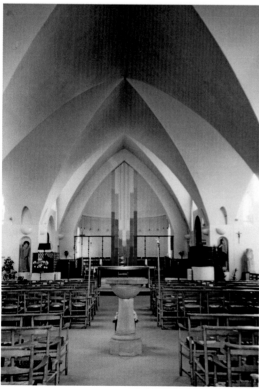

Levisham, St Mary's

The church of St Mary sits in the bottom of the beautiful Levisham Valley, which separates the hill top villages of Lockton and Levisham. Standing in isolation, it was once the centre of a small hamlet that appears to have shifted to the hilltop in the fifteenth century, possibly as a result of the Black Death. St Mary's was restored in 1884 only to fall out of use not too many years later when a new church was erected in Levisham village. Various schemes were proposed for the building but it was allowed to become a controlled ruin.

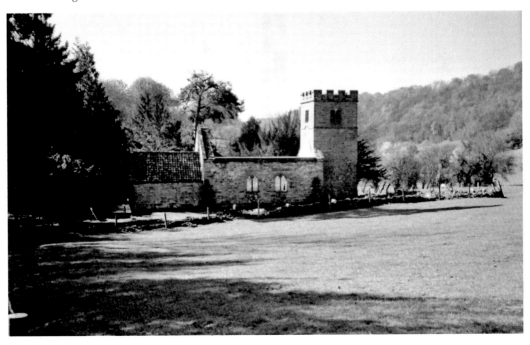

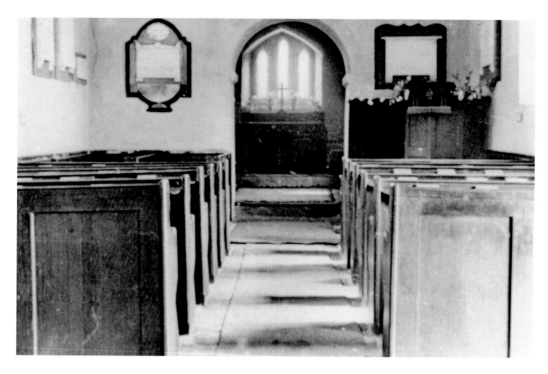

Levisham, St Mary's

The church possibly dates back to the twelfth century. Stripped of its plaster, the chancel arch reveals itself to be of Saxon or early Norman date. In the exterior walling of the church are numerous pieces of Saxon decorated stonework and a magnificent Saxon coffin was found with twining beasts. There is also the gravestone of a Norman knight inscribed with a sword.

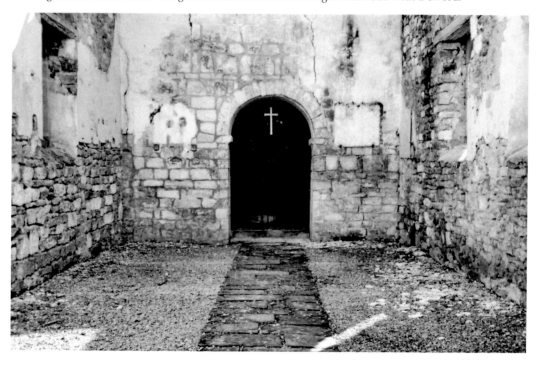

Little Ouseburn, Holy Trinity

Holy Trinity church, Little Ouseburn, is another Brontë church, insomuch that Anne Brontë worshipped here when she was governess to the children of the Robinson family of Thorpe Green Hall from 1841 until 1845. Holy Trinity features in her novel *Agnes Gray*. The church, with its eighteenth-century mausoleum by Henry Thompson for the Turner family, attendant yew trees and nearby Georgian bridge, is charmingly set on a bend in the road. The landscape retains the feel of an eighteenth-century park, much as Anne described it. Nothing in the structure of the present building can be safely dated from the original Norman foundation, although much of the tower appears to date from shortly after the Conquest using material salvaged from an earlier church. Mostly the edifice dates from the twelfth to fourteenth centuries, but was totally restored by 1952. Three Tudor bench ends survived this remodelling.

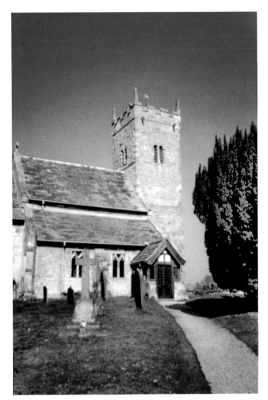

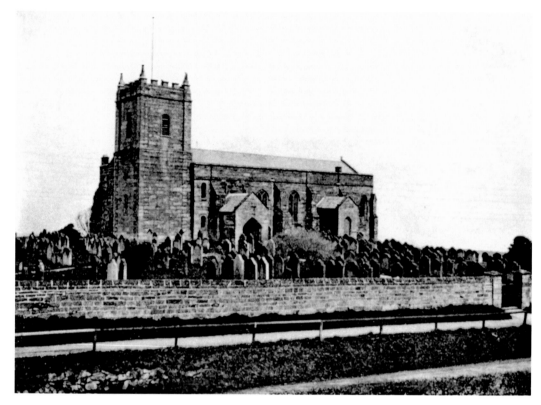

Lythe, St Oswald's

Those leaving Whitby by road via Sandsend, toward Teeside, will be familiar with the steep road known as Lythe Bank which arrives at the village of Lythe. Its parish church of St Oswald goes back to Saxon and Norman times but in 1910 plans were made to rebuild the old church, above. The foundation stone ceremony for the new church below took place on 29 September 1910. Built to the design of Sir Walter Tapper, it was officially opened on 9 October 1911.

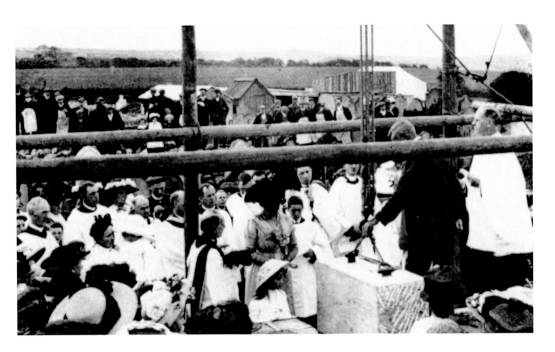

Lythe, St Oswald's

Having decided to use much of the old material the old church was carefully demolished, during which process thirty-seven Anglo-Scandinavian carved stones dating mainly from the tenth century were discovered. These Viking stones, mostly funeral monuments from a Christian graveyard, form one of the largest and most important collections in the country. They were cleaned and conserved by the York Archaeological Trust in 2007 and a selection was put on permanent display in a specially designed exhibition at the west end of the church in 2008.

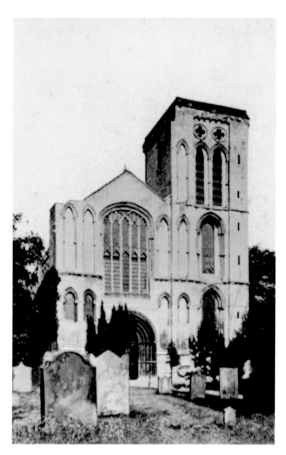

Old Malton, St Mary's

The church of St Mary at Old Malton comprises the western part of the nave of the great church belonging to Gilbertine Priory established here in 1150. The building combines Transitional Norman, Early English and Perpendicular work. The eastern part of the church and monastic buildings were destroyed in 1539 and the central tower was taken down about a century later. By 1732 further demolition and alterations had reduced the church to its present appearance. Inside there is some excellent woodwork in the choir stalls and misericords.

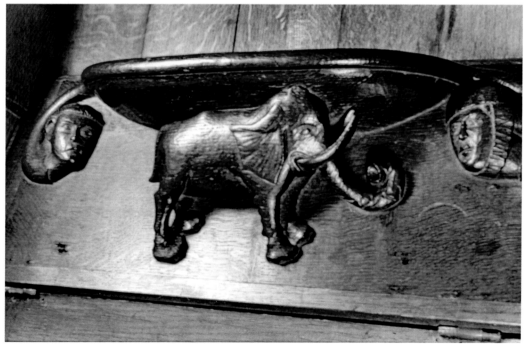

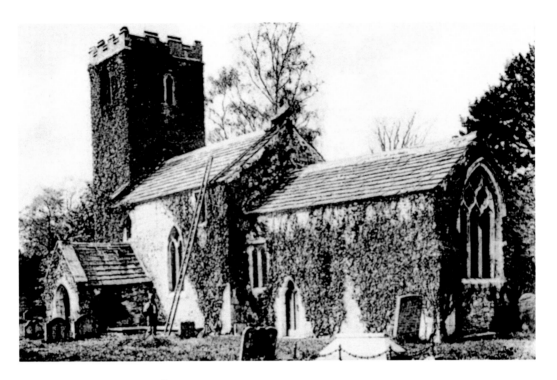

Newton Kyme, St Andrew

A superb image showing two labourers at work repairing the roof of St Andrew at Newton Kyme near Tadcaster, in 1903. This postcard view of the church has clearly been deliberately chosen by its sender; the message, to a Miss Alderson, reads, 'I hope you will come to Church on Sunday. You are getting a very wicked girl . . . Come in very good time as "Floaters" has taken a violent fancy for your seat'. Inside there is some old glass of note, and outside, a curious early twentieth-century brick monument in the churchyard.

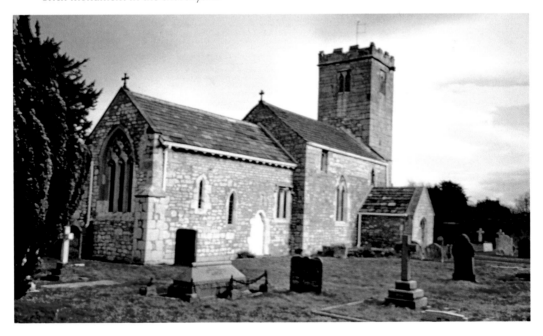

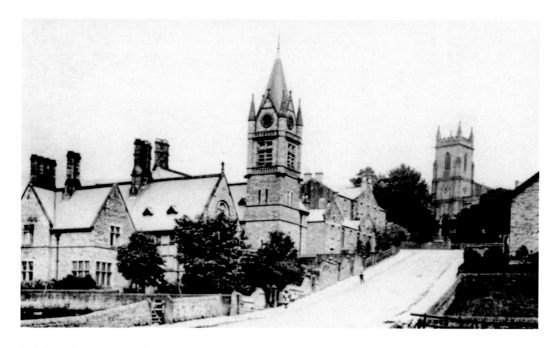

Pateley Bridge, St Mary's
The old parish church of St Mary at Pateley Bridge was erected in the thirteenth century but was replaced in 1827 by a new one dedicated to St Cuthbert, seen at the top of the steep main street of this famed market town. The old church still stands. It is little more than a roofless ruin but worth the visit if only for the magnificent views across the moors. This edifice is one of only fourteen surviving ruined churches in Yorkshire.

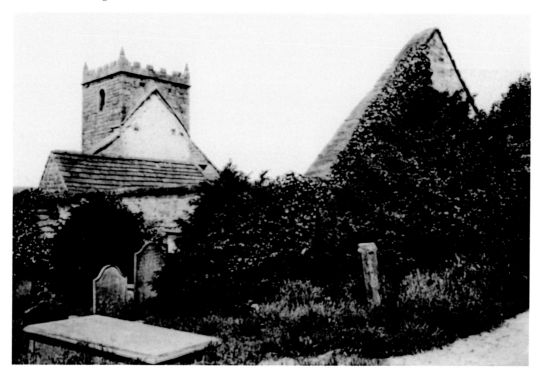

Patrington, St Patrick's

The church of St Patrick at Patrington, known as the 'Queen of Holderness' must rank as one of the most magnificent parish churches in England. It was erected almost entirely in the half-century after 1300, but the tower and spire, which rises up 189 feet, are of Perpendicular date. The chancel has a sedilia and piscina and a splendid Easter Sepulchre. The reredos behind the altar is by Harold Gibbons in memory of King George V. The medieval screen was restored at the end of the nineteenth century but we see the pulpit is dated 1612, and there are some Jacobean benches.

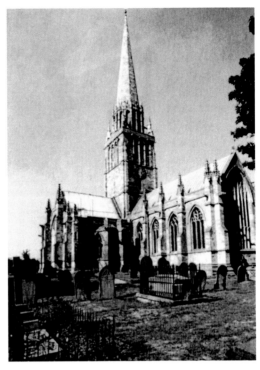

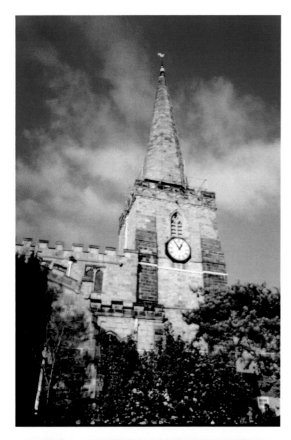

Pickering, St Peter and St Paul's

Of the Norman cruciform church of St Peter and St Paul's church, Pickering, only the arcades survive. The remainder is largely thirteenth- to fifteenth-century work. Said by some to be over-restored, there are nevertheless some fine original details. Most spectacular of all are the wonderful array of mid-fifteenth-century wall paintings discovered during the renovation work of 1831 and restored some thirty years later. Monuments include a wall tablet to a father and son who helped plan the city of Washington, USA and to John and William Marshall, the rural economists.

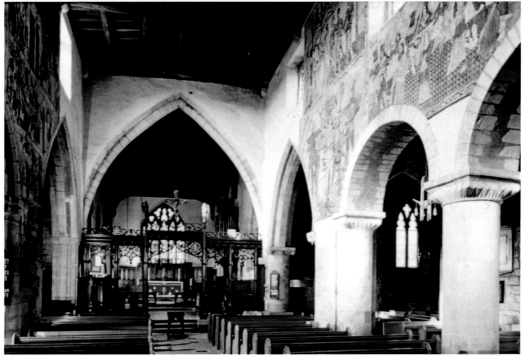

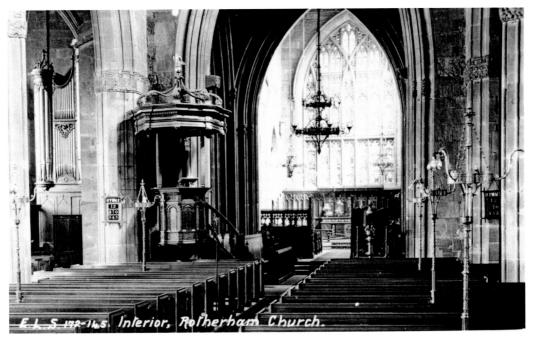

E.L.S. 192-145. Interior, Rotherham Church.

Rotherham, All Saints'

The splendid cruciform town church of Rotherham, dedicated to All Saints, is one of the most impressive churches in the county. It was restored in the 1700s and again in 1875. The majority of work dates from the perpendicular period, including the magnificent tower and spire, rising 180 feet. Inside there is a good panelled nave ceiling with bosses, fine stalls of 1452, contemporary benches and south chapel screen, and a pulpit dated 1604 with the large tester added a century later.

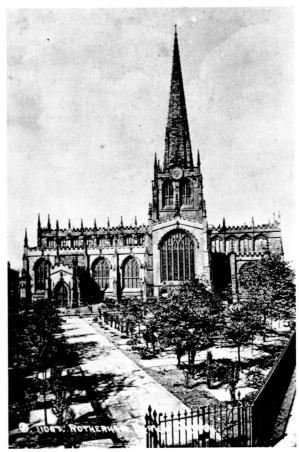

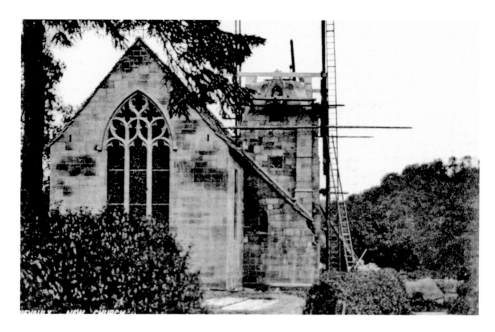

Rievaulx, St Mary the Virgin

Rievaulx takes its name from the French meaning 'The Valley of the Rye'. It was here in this secluded valley that a handful of monks founded Rievaulx Abbey in 1132. Eleven years later it is recorded that 300 persons were subject to the Abbot of Rievaulx. The village grew to provide accommodation for the large army of craftsmen who worked on the Abbey. William Wordsworth and his sister Dorothy visited here in July 1802 on their way to meet William's future bride at Brompton near Scarborough.

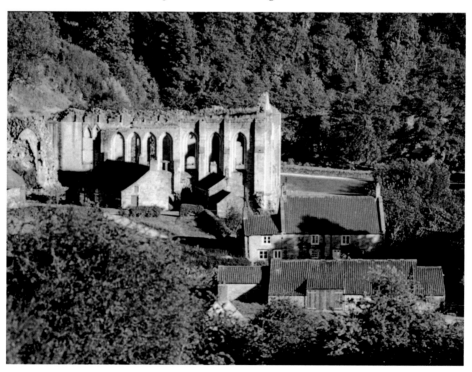

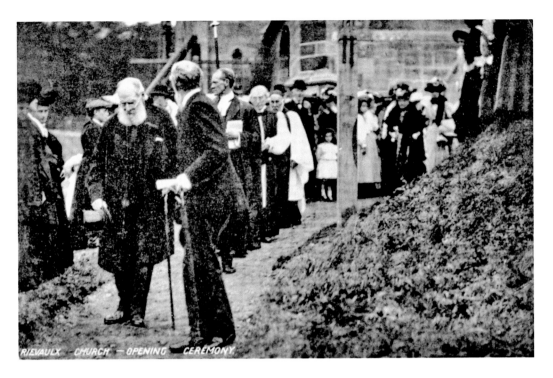

RIEVAULX CHURCH — OPENING CEREMONY

Rievaulx, St Mary the Virgin

With the dissolution of the Abbey and growth of the village came a need for a parish church to serve the community. A small chapel that stood outside the monastery gates was appropriated and later incorporated into the fabric of the present church that was built in 1906 and dedicated to St Mary the Virgin, which consists of a simple chancel and tower in the style of architecture known as Victorian Gothic, to which a spire was added later.

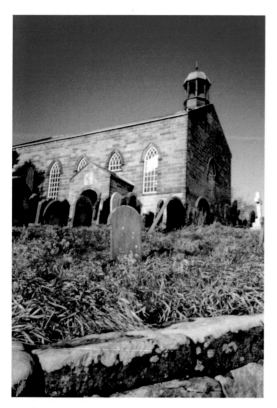

Robin Hood's Bay, St Stephen

The old church of St Stephen, perched on the hillside above at Robin Hood's Bay, is one of the churches the Victorians forgot. This complete, unspoilt Georgian church is now vested in the Redundant Churches Fund. Originally the parish church of Fylingdale, it was rebuilt on this ancient site in 1821, but fell out of use some fifty years later because of its remote position. There is a charming, late Georgian interior of box pews, west gallery and three-decker pulpit, and both inside and out there is a fine range of memorials to the shipwrecked.

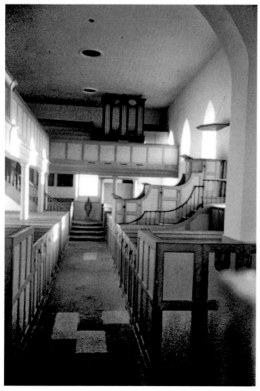

Rudston, All Saints'

Rudston is noted for the prehistoric monolith in the circular churchyard. This huge block of moorland grit is 29 feet high, and about the same depth underground. It is computed to weigh around 46 tons. Of glacial origin, geologists say it was probably deposited in the valley by a melting glacier, while archaeologists argue that prehistoric man hauled it from its place of origin. Whatever, it was subsequently erected on the hill and became a focus point for ritual worship. The name of the village is possibly derived from the stone.

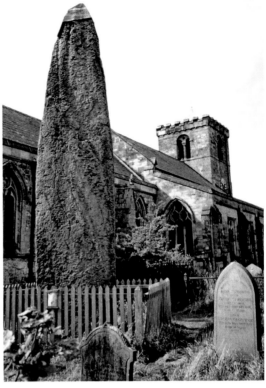

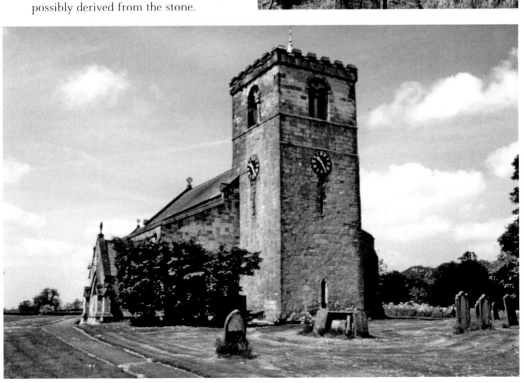

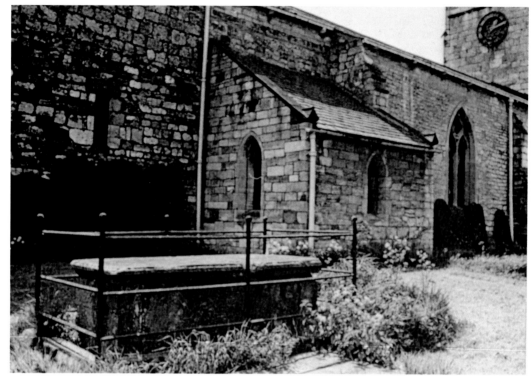

Saxton, All Saints'

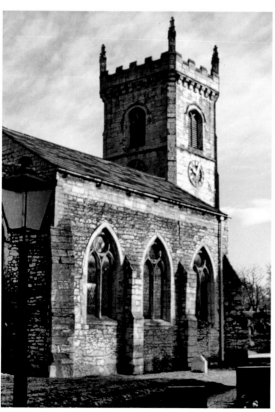

All Saints, Saxton, dates largely
from the thirteenth and fourteenth
centuries but has a Norman chancel
arch and Perpendicular tower. There
is a fragment of Anglo-Saxon cross,
possibly of tenth-century date, and
a nice monument by J. F. Moore to
two Hawke children dated 1783. The
chancel was restored and refurbished
in 1876. Outside is the tomb of Lord
Dacre, killed at the battle of Towton in
1461. It is rare to find an altar tomb of
this age, let alone of such an eminent
person, in a churchyard.

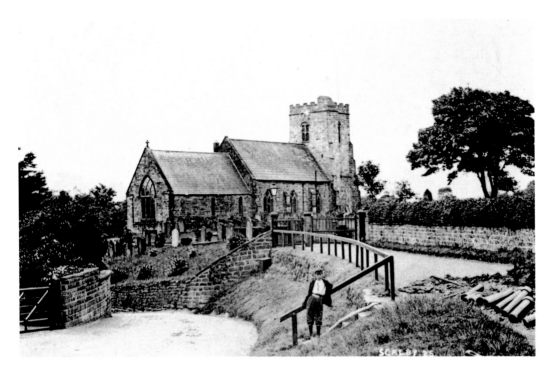

Scalby, St Laurence

The church of St Laurence, Scalby, stands 'upon a gentle elevation at the western extremity of the village . . . and is a very picturesque object.' It dates from before 1180, was rebuilt in 1683, from which year the tower dates, and was further enlarged in 1887. There is a Jacobean pulpit with an hourglass stand, and an old poor box. The list of vicars includes the brother of the Yorkshire geologist Adam Sedgwick of Dent, and William Mompesson, the hero of the Derbyshire plague village of Eyam.

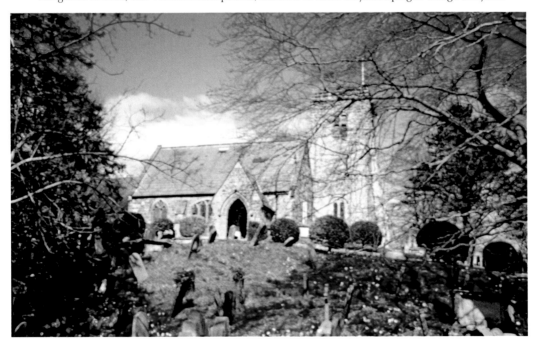

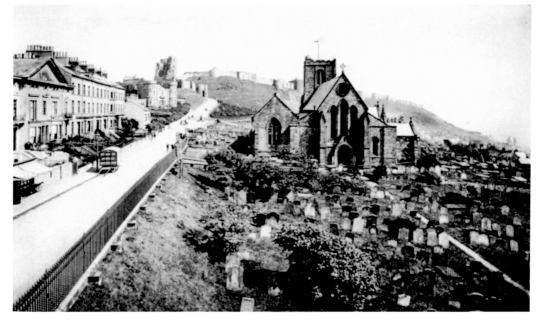

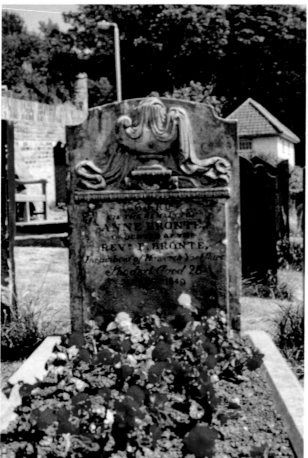

Scarborough, St Mary
The church of St Mary, Scarborough, was founded as a priory in the late twelfth century and suffered partial destruction during the Civil War. It was formerly a cruciform church. The weakened tower collapsed in 1659, and was rebuilt a decade later. The two-storey porch and range of late fourteenth-century chapels off the south aisle have tunnel vaults. Good monuments including one by the French sculptor Louis Francois Roubiliac, 1728, and numerous brass plaques taken from the churchyard headstones. In the detached churchyard is the grave of Anne Brontë, *d.* 1849.

Selby, Abbey Church of St Mary and St Germaine

This great cruciform church is all that remains of the Benedictine Abbey established here in about 1069. The present building was begun in about 1100. The fine west front combines work of the twelfth to fourteenth centuries. The church has a good Norman and Early English porch and the chancel is a splendid example of the Decorated style. The church has undergone several restorations and parts have been rebuilt. The first restoration took place when the upper part of the crossing tower collapsed in 1690, destroying the south transept.

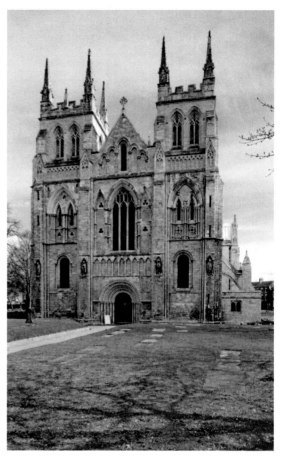

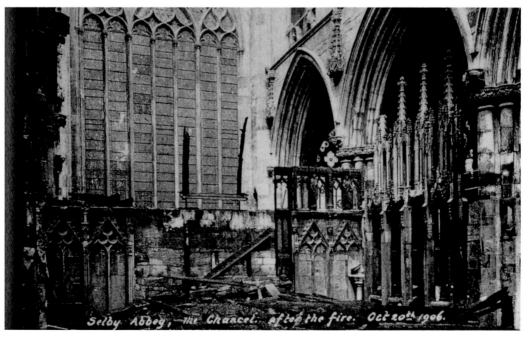

Selby Abbey, the Chancel after the fire. Oct 20th 1906.

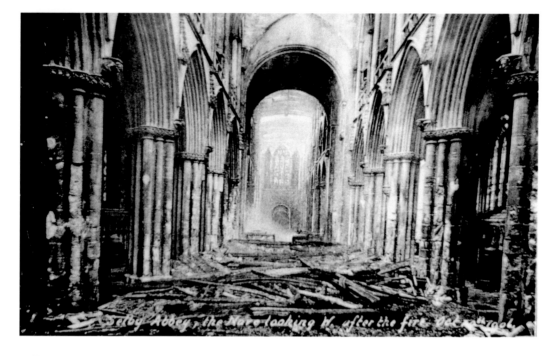

Selby, Abbey Church of St Mary and St Germaine

It was again remodelled and the transept rebuilt after the building was devastated by fire in 1906: it was in this year that the San Francisco earthquake took place. The fifteenth century cover of the Norman font was one of the few pieces of woodwork to survive the fire. The top stages of the two west towers were added in 1936. Much original glass was lost, but medieval glass in the chancel includes the arms of the Washington family that gave the United States its first president and forms the basis of the American flag.

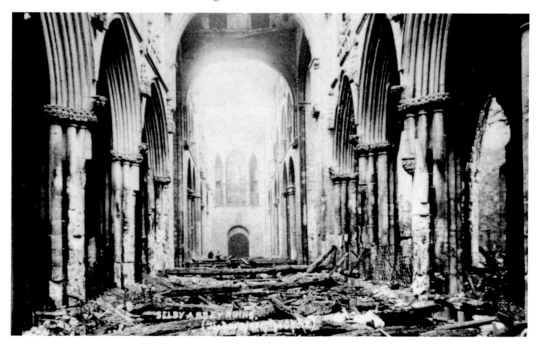

Sherburn-in-Elmet, All Saints

The church of All Saints, Sherburn-in-Elmet. The town's name comes from the ancient kingdom of Elmet. The church is externally of mainly Perpendicular date with an Early English chancel, but there is much Norman work surviving in the powerful arcades and lower part of the tower. There is a superb and rare fifteenth-century Janus crosshead, sawn in half and mounted so that both faces can be viewed, a somewhat drastic solution. In the churchyard, near the porch, is the round head of a Saxon cross on a later shaft.

The mortal remains are deposited in the Graves as undernamed,
1st Grave begining at the North end,
George Birkinshaw Aged 10 Years }
Joseph Birkinshaw Aged 7 Years } Brothers.
Isaac Wright Aged 12 Years }
Abraham Wright Aged 8 Years } Brothers.
2nd Grave.
James Clarkson Aged 16 Years.
Francis Hoyland Aged 13 Years.
William Atick Aged 12 Years.
Samuel Horne Aged 10 Years.
3rd Grave,
Eli Hutchinson Aged 9 Years.
George Garnett Aged 9 Years.
John Simpson Aged 9 Years.
4th Grave,
George Lamb Aged 8 Years,
William Womersley Aged 8 Years
James Turton Aged 10 Ye...

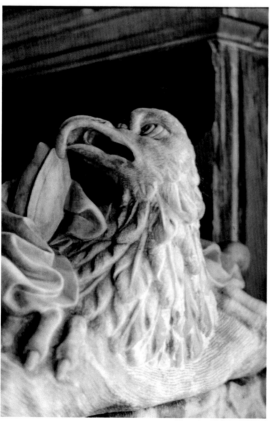

Silkstone, All Saints'

Although the West Yorkshire church of
All Saints at Silkstone has stonework
from the thirteenth-century cruciform
church, most of the present building
is Perpendicular work. The main
exception is the chancel, which was
rebuilt about 1895. Inside there is
medieval woodwork in the screens,
nave and aisle roofs. The box pews and
pulpit date from 1835 and there are
marvellous monuments with effigies
to Sir Thomas Wentworth (d. 1675)
one of which has a phoenix bird at
the foot. There is also a memorial in
the churchyard to twenty-six boys and
girls who drowned when a coal mine
flooded in 1838.

Skelton, Old Church, All Saints'
The old church at Skelton was erected in 1785, almost certainly at the expense of John Hall Stevenson of nearby Skelton Castle. The church was built on the foundations of its predecessor, which was constructed by the Fauconberg family of Coxwold in 1325. On the north side part of the medieval church remains in the stonework. John Hall Stevenson was a cultured man and friend of Revd Lawrence Sterne of Coxwold. The church has a severe interior with box pews, two-decker pulpit and a single gallery; the other was taken down.

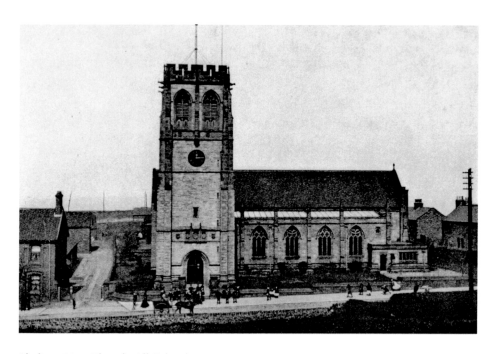

Skelton, New Church, All Saints'

The new church at Skelton was opened by the Archbishop of York on 14 October 1884 and was erected at a cost of £13,476 mostly donated by the Wharton family of Skelton Castle. It is built in the Victorian Gothic style to the design of R. J. Johnson, architect of Newcastle, using local stone quarried at nearby Glaisdale, and Skelton and Skelton Shaft. Over the main entrance located in the tower, are five coats of arms carved in stone – Trotter, Unidentified, Brus, Conyers, Wharton – achieved through marriage.

Skipton, Holy Trinity

Standing at the top of the main street in Skipton is Holy Trinity church, adjacent to Skipton Castle. It was restored in 1655 by Lady Anne Clifford of the castle, after it sustained damage in the Civil War. Its architecture is mostly Perpendicular with some from the Decorated period. Inside there is a good medieval roof and chancel screen of 1533. There are also the remains of an anchorite cell near the west end of the north aisle, and the chancel is dominated by the Clifford family tomb chests.

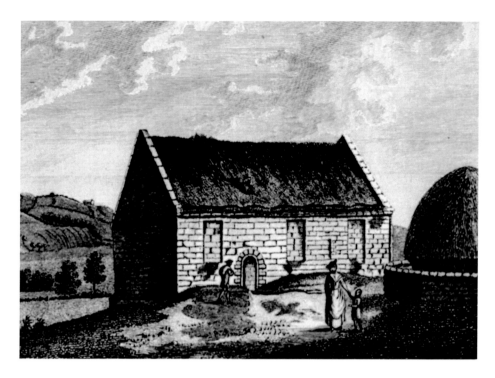

Eskdale Chapel and Sleights, St John's

The ancient chapel on Eskdaleside, shown in this engraving dated about 1774, when it had not long closed and was being used as a cow shed. Its origins lay in the thirteenth century, and it is locally known as 'The Hermitage'. It is connected with the ancient Whitby custom of the 'penny hedge ceremony'. Today, its scant remains can be found down a country footpath and it is now a Grade II listed monument in the care of English Heritage. The church below replaced the chapel and was sited nearer the village proper.

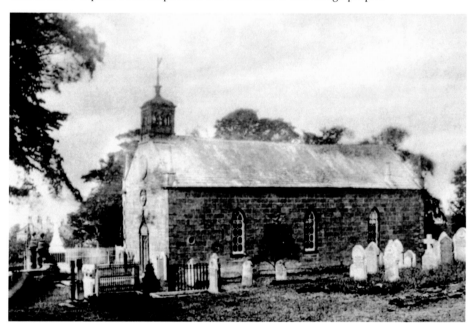

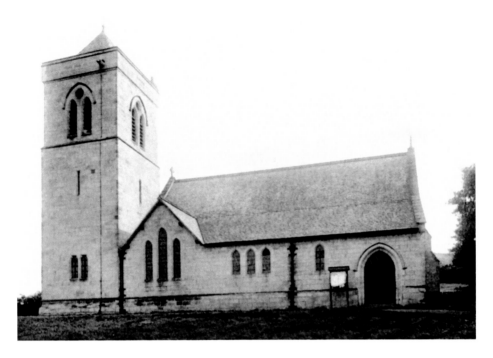

Sleights, St John's

In turn, the mid-eighteenth-century Georgian church of St John was replaced by this Victorian edifice, which opened on 20 September 1895 at a cost of almost £5,000. Photographed by Tom Watson of Lythe, it was built in the Early English style, with triple lancet windows. The parish, of which it is the parish church, is more correctly known as Ugglebarnby-cum-Eskdaleside and served a number of surrounding hamlets – Iburndale, Littlebeck, Ugglebarnby and farms along Eskdaleside. Above, the churchyard has yet to receive any burials and no trees hide its newness.

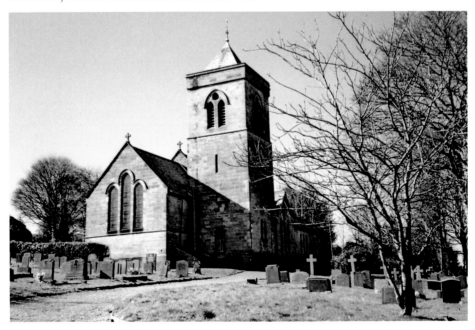

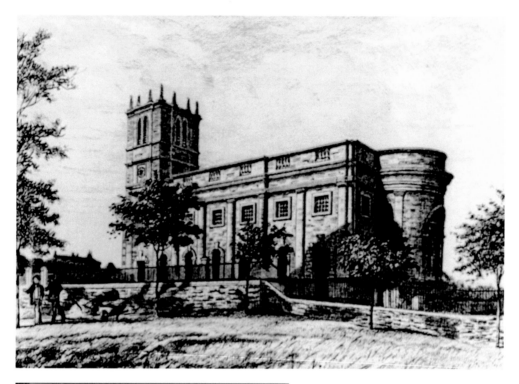

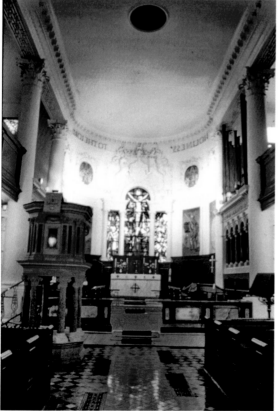

Sowerby, St Peter's

An exterior portrait of St Peter's, Sowerby, near Halifax, in 1855. The Revd John Watson wrote of the recently completed church that it was 'one of the most elegant . . . in the North of England'. It was the work of John Wilson, a master mason from Halifax, who was selected by the trustees in 1759 as 'a Proper Person' to make a design as well as to undertake the masonry. A Palladian basilica with a formal Classical façade, later complemented by the charmingly incongruous Gothick tower, closely followed the original design.

Sowerby, St Peter's

Dour on the outside, nothing prepares you for the sumptuous interior. Sowerby surpasses all in the quality of the richly decorated apse, unmatchable elsewhere in the county. The two rows of giant Corinthian columns lead a worshipper's eyes towards the east end where the central Venetian window is flanked by figures of Moses and Christ, and the austerely noble architecture flowers in an exuberant display of rococo plasterwork executed in 1766 by Giuseppe Cortese, an Italian stuccatore who spent most of his working life in Yorkshire.

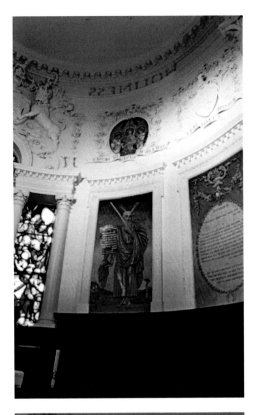

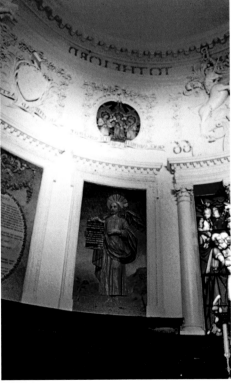

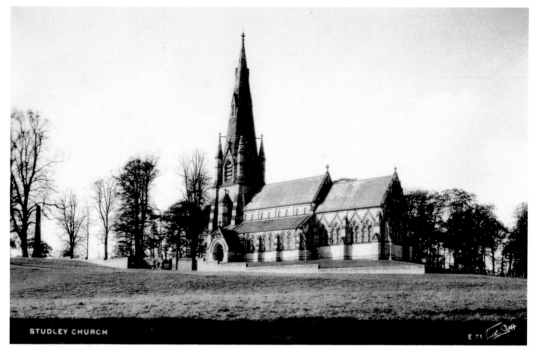

STUDLEY CHURCH

E 71

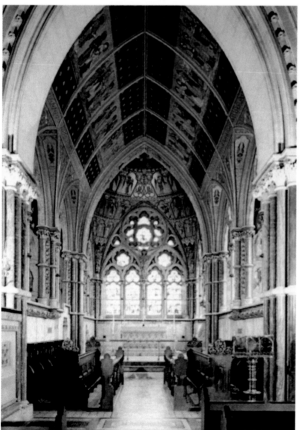

Studley Royal, St Mary

Studley Royal, St Mary, built by William Burgess for the Marchioness of Ripon in 1871–78, has been described as 'one of the most perfect churches in the kingdom'. Impressive on the outside, it forms a focal point in the landscaped Studley estate alongside Fountains Abbey. Inside, it is even more impressive than the exterior, a sumptuous and glorious blend of marbles, alabaster, mosaic and paint create a vibrant multicoloured picture. Excellent stained glass designed by Frederick Weeks dates from 1878, and a fine tomb commemorates the founder, dating from 1908.

Thirsk, St Mary's

The church of St Mary at Thirsk is one of the most impressive churches in North Yorkshire. Perpendicular style throughout, work began about 1430 and continued into the following century. It was well restored by George Edmund Street in 1877. The nave has a fine wagon roof, and there is other medieval woodwork in the parclose screens, doors, bench ends and the font cover. There are fragments of old glass, wall paintings and among the monuments is a small brass of 1419 dedicated to the priest Robert Thirsk.

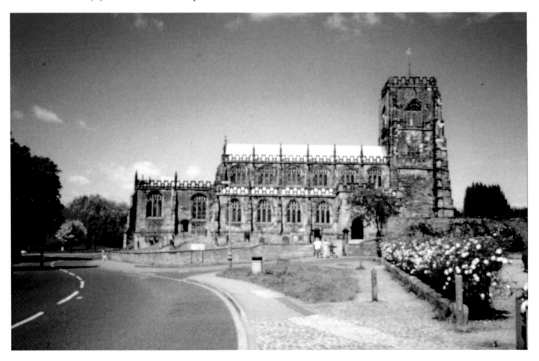

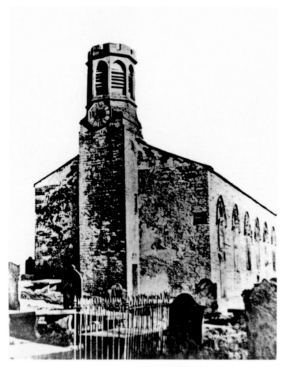

Thornton, St James's

As seen here, the old chapel of
St James, whose ruins stand in the
redundant graveyard across from the
present parish church of Thornton,
represents the tireless zeal and
enterprise of the Revd Patrick Brontë,.
Following the restoration, a dated
wooden board on the exterior bore
witness to this fact. It read 'This Chapel
was Repaired and Beautified 1818.
P. Bronte, incumbent'. His 'repairs'
entailed the demolition and rebuilding
of the south wall with the insertion of
spacious windows and the complete
re-roofing of the church.

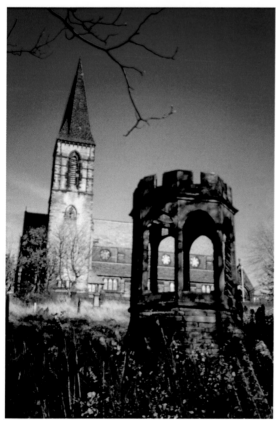

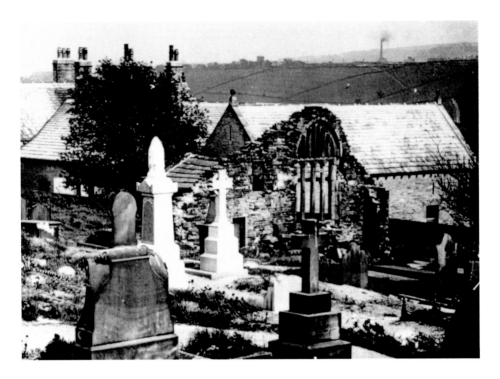

Thornton, St James's

The Revd Brontë had erected an octagonal cupola and the 'old' bell replaced inside, which led to the local name of 'owd bell chapel'. The remaining east wall has a number of inscribed dates and inscription in the masonry from earlier churches dating from 1587, 1612 and 1756. After a campaign by SPEC the ruins of the old Bell Chapel are now a Grade II listed building and have been landscaped in recent years for the village to enjoy as a public amenity.

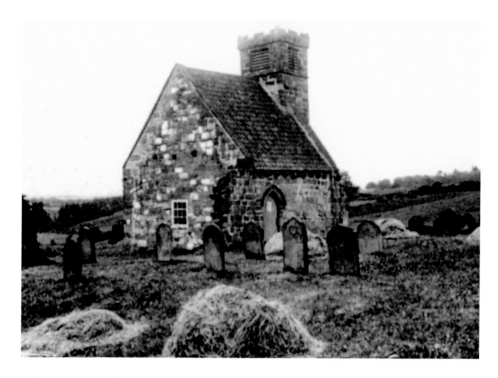

Upleatham, St Andrew

The church at Upleatham in 1923. Often stated as being the smallest church in England, it was built in 1684 but the main body of the church was demolished in 1822, leaving the tiny chancel to serve the parish. By 1966 the church was in a poor state of repair. A company of soldiers from the Green Howards voluntarily restored the building and as a thank you to them a plaque was placed inside the church. The church is now redundant, replaced by a nineteenth-century masterpiece by Ignatius Bonomi nearer the village.

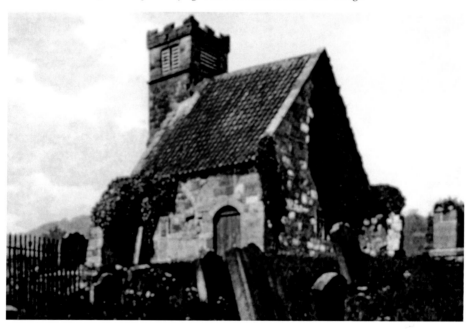

Wensley, Holy Trinity

The North Yorkshire church of Holy Trinity, Wensley, is all that a medieval church should be. There are Anglo-Saxon fragments suggesting ancient origins and mid-thirteenth-century chancel with good sedilia and piscina. The arcades, chancel arch and aisle windows date from around 1300. The two-storey sacristy with barred upper windows is Perpendicular. Inside there are some remarkably interesting furniture and fittings; remains of fourteenth-century murals, early wood benches, box pews, and a fifteenth-century box alleged to be a reliquary and sixteenth-century screenwork, both taken from Easby Abbey, to name just a few. Here we see another interesting feature, the very fine Flemish brass to the priest Sir Simon de Wenslaw, dating from 1394.

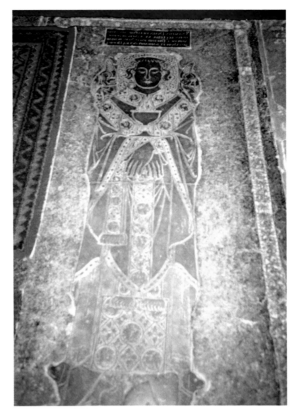

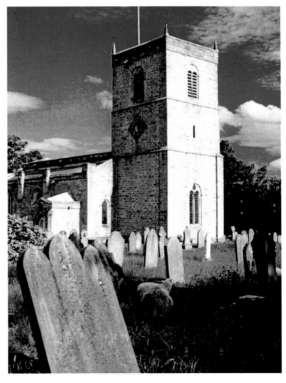

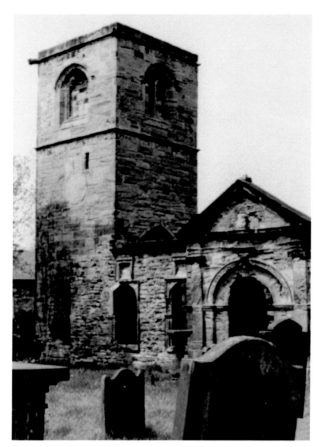

Wentworth, Holy Trinity
Although ruined, the old church
at Wentworth, replaced by a
new church in 1877, has some
fine coloured glass attributed
to William Peckitt. There is
also a collection of interesting
monuments to the Wentworth
family in the surviving north
chapel, including one to the
1st Earl of Stafford, who was
beheaded by Parliament in 1641.
The Decorated tower, nave,
chancel and imposing porch were
all remodelled in 1684. They are
now ruins, though they were
restored and consolidated in 1925.

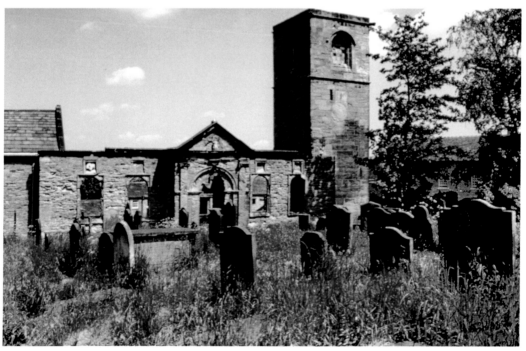

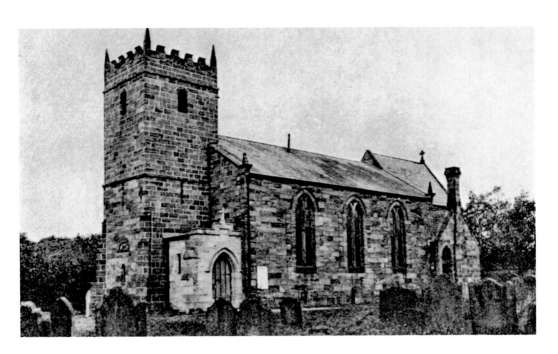

Westerdale, Christ Church

The sturdy nineteenth-century church at Westerdale, high in the dales of the North Yorkshire moors is dedicated to Christ Church. Little is known of the religious life here before the present edifice, but there is also a Nonconformist chapel in the village dating from the early nineteenth century. It is known that the Order of the Knights Templar had a preceptory in the area at the time of the suppression of the Order in 1308, so undoubtedly there would have been a place of worship here.

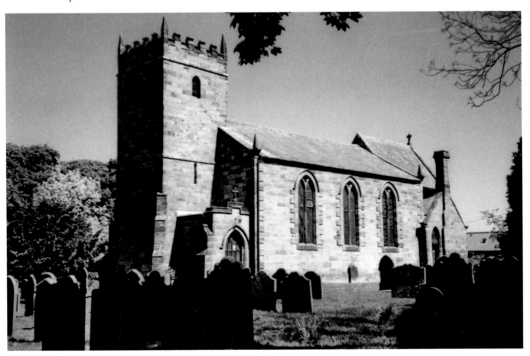

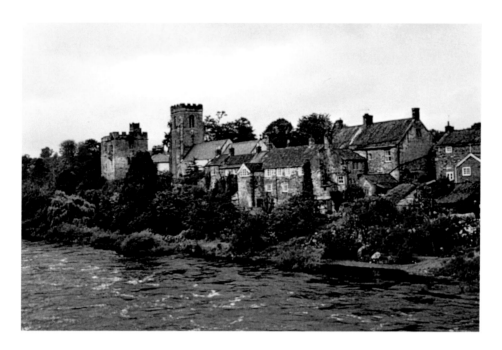

West Tanfield, St Nicholas

The church at West Tanfield, dedicated to St Nicholas, mostly comprises of Perpendicular architecture but retains a thirteenth-century doorway and arcades. Unfortunately it was heavily restored in 1860. In the north wall of the chancel is a curious small chamber that may have been a chantry chapel. There are numerous medieval monuments to the Marmion family whose castle gatehouse neighbours the church. In particular is one of a knight and his lady which is rare in still having its original wrought ironwork to support a pall and sconces to hold candles.

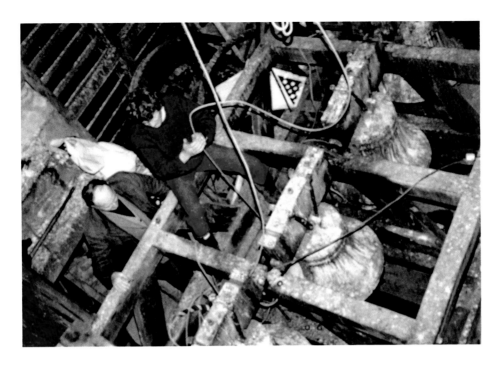

West Tanfield, St Nicholas

In 1944 the bells were found to be defective and a scheme was put in hand to have them removed and renewed. As a consequence of this the eight bells were taken to London and recast, and here we see the bells firstly above, *in situ* before removal and below, recast and stood in the bell foundry yard to weather and cool before being returned to the church and rehung. These few photographs are some of a series taken throughout the entire removal and refitting.

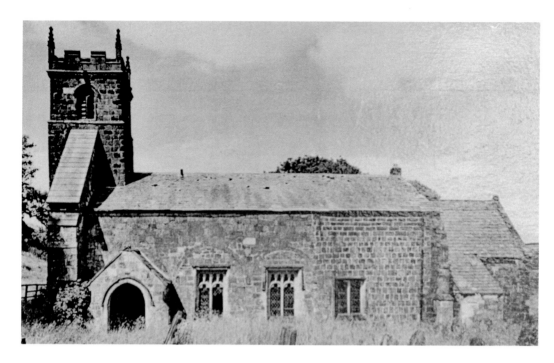

Wharram Percy, St Martin's

Wharram Percy today is what is known in archaeological terms as a Deserted Medieval Village (DMV) site. As a DMV the site has been a major archaeological teaching resource for over fifty years. Each season, students came here to learn excavation techniques. The exploration of this village has revealed that it had manor houses, a water-powered corn mill, a dovecote and the church, which was probably the last building to surviving in use (above). However, today St Martin's is also a melancholic ruin.

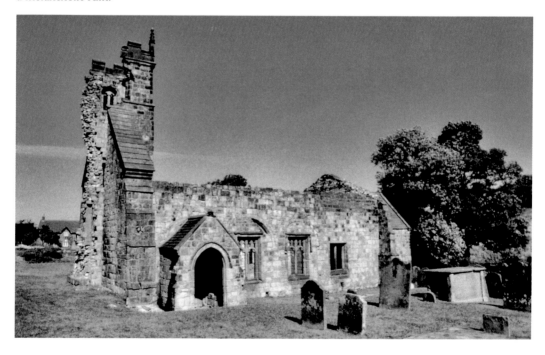

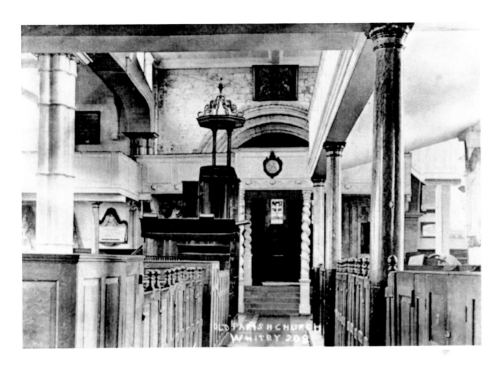

Whitby, St Mary's

The church of St Mary at Whitby has its roots deep in antiquity, evident in the number of Anglo-Saxon fragments recovered at various times. The chancel is Norman and the tower dates from the same period. However, much is obscured by the heavy and insensitive Georgian remodelling. The interior is a unique and delightful example of a surviving post-Reformation arrangement, presenting a quirky mass of box pews and galleries lit with domestic-style windows. Cholmley pew hides the Norman chancel arch and there is a fine three-decker pulpit of 1778 and Baroque chandelier of 1769.

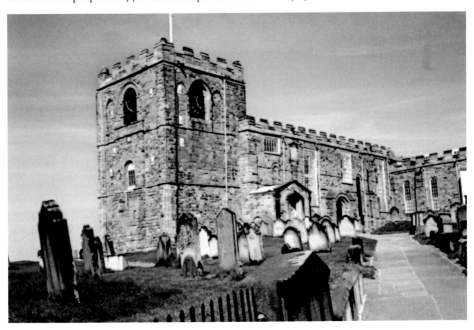

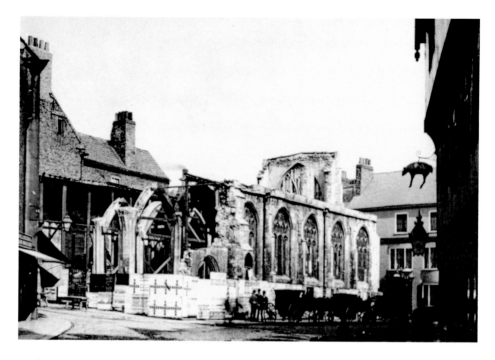

York, St Crux

York, the Northern capital has a great number of medieval churches surviving, but equally it has lost many. Here we see the demolition of the church of St Crux, which stood on the corner of the Shambles and Pavement until 1887. Below, St Crux Parish Room, which must have stood behind the church, as the building with chimney pots, is the same in both photographs. This building has managed to survive and is often used today as a café raising funds for church projects.

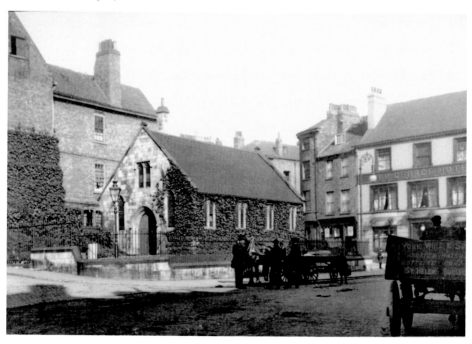

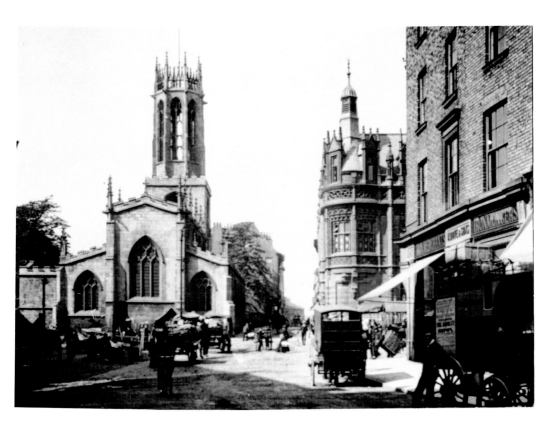

York, All Saints, Pavement

York, All Saints, Pavement. A fire was lit in its distinctive lantern as a beacon for travellers making their way to the city through the Forest of Galtres that surrounded York during the Middle Ages. The lantern was reconstructed during the restoration of 1837. All Saints was deprived of its chancel to allow for road widening in 1782, but nonetheless this fifteenth-century church is still impressive. It houses an excellent fifteenth-century lectern from the church of St Crux, and some stunning medieval glass.

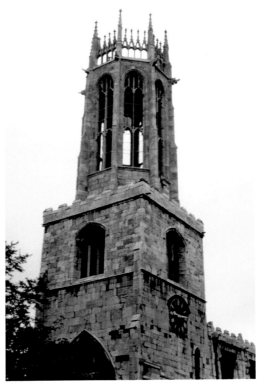

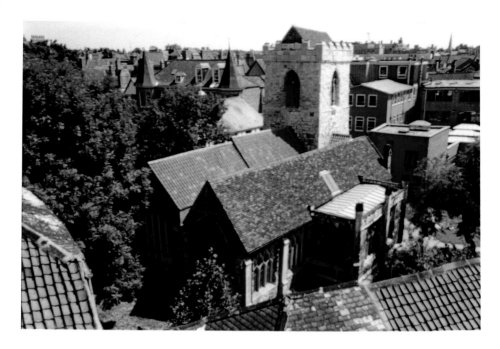

York, Holy Trinity, Goodramgate

York, Holy Trinity, Goodramgate is approached through a late eighteenth-century brick archway or from another direction, along a snickelway, but whichever, the church in its small churchyard cannot be seen from the street, being totally hemmed in on all sides by buildings. A saddleback roof covers a delightfully giddy interior with not a right angle in sight. Its many interesting features include seventeenth- and eighteenth-century box pews, a two-decker pulpit of 1785, altar rails and reredos of 1721 and the magnificent east window of five lights donated by the rector in 1470.

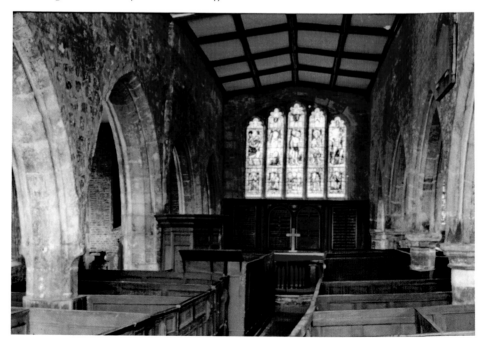